GAUGUIN

GAUGUIN

Alan Bowness

with notes by Lesley Stevenson

Phaidon Press Limited
140 Kensington Church Street, London W8 4BN

First published 1971
This edition, revised and enlarged, first published 1991
Second impression 1992
© Phaidon Press 1991

A CIP catalogue record of this book is available from the British Library.

ISBN 0 7148 2683 9

Printed in Hong Kong.

The publishers wish to thank all private owners, museums, galleries and other institutions for permission to reproduce works in their collections.

Cover illustrations:
(front) *Woman Holding a Fruit*. 1893. (Plate 37) State Museum of New Western Art, Moscow.
(back) *Manao Tupapau (The Spirit of the Dead Keeps Watch)*. 1892. (Plate 33)

Gauguin

More than with most painters, the shape of Gauguin's turbulent career was predetermined by his heredity and early environment. The popular idea of the successful business man who suddenly and surprisingly decided to be a painter could scarcely be further from the truth. What is more remarkable, indeed, is how closely the art which Gauguin created and which was to have such a widespread influence responded to his private needs. His life and work were dominated by the feeling that he must somehow recapture a lost paradise dimly remembered from early childhood. Unable to find it, he remade it in his own art, but only at the cost of self-destruction. The drama was played out over little more than twenty years, against a background of the most momentous changes in the history of art since the Renaissance. And although Gauguin may not have been the greatest artist involved, his contribution was arguably the major one.

Eugène-Henri-Paul Gauguin was born in Paris on 7 June 1848, at the most violent phase of the 1848 Revolution - a propitious enough moment. His father, Clovis Gauguin, was a 34-year-old journalist, who worked for a liberal newspaper that was soon to be suppressed. Clovis came from Orléans, and there is nothing in the Gauguin family history of market gardeners and small business men to suggest an artistic temperament.

With Clovis's wife, Aline-Marie Chazal, it is a very different matter however. She was only 22 when her son was born, and already had a one-year-old daughter, Marie, Paul's only sibling. Aline was the daughter of André Chazal, engraver, and of Flora Tristan, author and social reformer. Theirs had been an ill-matched, short-lived marriage; it culminated in Chazal attempting to murder his wife and being sentenced to twenty years' imprisonment.

Paul owed much to this tempestuous pair. The Chazals were a family of artist-engravers of modest talent and considerable industry. André might have won conventional success and shown his work at the Salon as his brother did, had he not employed as a colourist in his workshop the 17-year-old girl who was to become his wife.

Flora Tristan was the illegitimate daughter of a young woman, Thérèse Laisnay, of whose background nothing whatever is known. She seems to have fled to Spain at the French Revolution, though whether she was an aristocrat or an adventuress, it is impossible to say. In Bilbao she became the mistress of a well connected Spanish colonel of Dragoons, Don Mariano de Tristan Moscoso. They moved to Paris where Flora was born in 1803: the liaison was a stable one, but Don Mariano died suddenly before bringing himself to marry his mistress. This catapulted her from luxury to penury, and the rest of her miserable life was spent pleading the claims for herself and her daughter.

She had grounds for feeling that she was owed something. The Tristan Moscoso family belonged to the old Aragonese nobility, and

Fig. 1
Photograph of Paul
Gauguin in 1873

were among the early Spanish settlers in Peru, where they had become powerful and extremely wealthy. Gauguin liked to believe that they had intermarried with the Inca aristocracy, and this is certainly possible. Don Mariano's brother, Don Pio, took part in the early nineteenth-century War of Peruvian Independence, and was Viceroy for a time. It was to him that Flora, having deserted her dull husband, appealed. He agreed to make a small allowance to his niece, and thus encouraged Flora set sail for Peru, in the hopes that a personal appeal would bring her a larger share of the considerable family fortune.

She was wrong, but a by-product of her South American trip was the book, *Pérégrinations d'une Paria (Wanderings of an Outcast)*. Published in 1838, this made Flora Tristan's literary reputation, and launched her in the world of letters. She wrote a novel, but soon turned to social reform and espoused the revolutionary working class movements of the day. Followed by police spies, she travelled France addressing meetings of the urban proletariat whom she called upon to unite. Physically exhausted by such activites, she collapsed and died in Bordeaux in November 1844, less that four years before the revolution of 1848 to which she had made such a signal contribution. Paul Gauguin idolized his grandmother, and kept copies of her books with him to the end of his life.

Like many other European intellectuals, Clovis was forced by the failure of the 1848 revolutions to look to the new world. There was no future for a liberal journalist in the France of Louis Napoléon. No doubt impressed by his wife's South American connections, he decided to emigrate to Peru and start a newspaper there. Unfortunately, although aged only 35, he died of a heart attack on the long voyage round Cape Horn, and was buried in Patagonia. With her two babies, his young widow had no choice but to complete the voyage.

On arrival in Lima, Aline was well received by her Spanish grandfather's younger brother, Don Pio de Tristan Moscoso. His position in Peruvian society is indicated by the fact that, only a few months after Aline's arrival, Don Pio's son-in-law, Echenique, became President of Peru. Aline and her two young children consequently found themselves in a tropical paradise where every material need was met and every sense was indulged.

'I have a remarkable visual memory, and I remember that period, our house and a whole lot of events', Gauguin said later. He was an eighteen-month-old baby when he arrived in Lima, a six-year-old boy when he left, and one can imagine the indelible impressions of Peru that haunted him all his life. The small child grew up bathed in the dry heat and the brilliant sunlight, surrounded by the shapes and scents of an exotic vegetation, and no doubt endlessly cherished by his colourful relatives and their many servants. Aline and her two children were looked after by a Negro nurse-maid and a Chinese manservant; and the racial diversity of Peru was matched by a rich extravagance of dress and by the brightly painted buildings everywhere in the city.

Suddenly for the child Gauguin this world disappeared, and he was flung into the grey, miserable, money-scraping existence of provincial France. He could hardly have appreciated the sequence of events - a civil war in Peru which resulted in Don Pio's family losing political power, Aline's return to France anticipating grandfather Gauguin's death, life with Clovis's bachelor brother in Orléans, a small legacy from the Gauguins, and a large annuity from Don Pio, which his family prevented Aline from ever receiving. Eventually she established herself as a dressmaker in Paris, leaving Paul at

boarding school in Orléans.

It is not surprising that his one ambition was to escape, and find again that lost paradise of childhood. Gauguin had a strong practical streak, and the obvious solution was to go to sea as soon as he was old enough. So, in December 1865, the three-master *Luzitano* left Le Havre for Rio, with the 17-year-old Paul on board. For two years with the merchant marine, and a further three with the French navy, Gauguin sailed the world, crossing the Pacific, patrolling the Atlantic, seeing naval action in the Franco-Prussian war. He did not in fact return to Peru: perhaps the occasion never arrived, perhaps he would not have taken it even if it had.

During his longest voyage away, Gauguin's mother died. Though only 41, her health had been declining, and in her last years she had lived in semi-retirement in Saint Cloud. A wealthy banker neighbour, Gustave Arose and his wife, had taken an interest in Aline and her children, and Arosa was named their legal guardian in her will. It was an excellent choice. When in 1871 Paul decided that the rootless, wandering life of the sailor was after all not for him, Arosa found him an opening as a broker's agent in the Paris stock exchange.

Gauguin settled down to bourgeois existence in Paris very quickly. In November 1873 he married Mette Gad, a young Danish governess whom he had met not long before (Fig. 2). In 1874 the first of their five children was born. Gauguin was only a tolerably successful business man, but in 1880 the young couple were able to move to a large, comfortable suburban house in Vaugirard with a garden for the children and a studio for Paul to paint in.

For already Paul's 'hobby' was beginning to take up more and more of his time and his energies. It seems probable that he began painting in the summer of 1873, when his fiancée was at home in Denmark preparing for the wedding. Mette claimed that she did not know of her husband's painting activities when she married him and there is no reason to disbelieve her. The introduction to art, like the introduction to Mette, came through Gustave Arosa. He was an enthusiast, with an excellent private collection of modern paintings - many works by Delacroix, some Corots, Courbets, Jongkinds, Pissarros, as well as pieces of oriental and exotic pottery. Arosa's daughter Marguerite was a Sunday painter, and it was probably she who introduced Paul to brushes and canvas, perhaps to pass the time while Mette was away.

Admittedly Gauguin had no formal training and attended only a few classes at art college, but it is worth emphasizing that he started painting when just 25, that he devoted a great deal of time to it, and that he benefitted from the particularly valuable kind of instruction which ownership of works of art can bring. Emulating his guardian, he had begun to collect as well as paint, buying the works which he needed to study to further his own artistic career. At first he chose straightforward naturalistic landscapes by Jongkind and Pissarro, then bought representative examples of others associated with the revolutionary Impressionist group - Manet, Monet, Renoir, Degas and, most difficult but most rewarding of all, Cézanne. Most of Gauguin's picture-buying was done in 1879, a year when spare cash was easily available. This patronage in turn made it easier for Gauguin to show his own paintings in the exhibitions of the Impressionists.

The major influence on Gauguin in this early phase of his career was certainly that of Camille Pissarro (Fig. 3). Always kind, generous, believing well of everyone, Pissarro had a William Morris-like faith in the latent artistic talents of everyone, and a remarkable

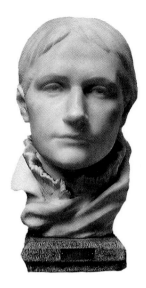

Fig. 2
The Artist's Wife, Mette
1877. Marble. Courtauld Institute, London

nose for exceptional men of genius. His advice and encouragement meant much to Gauguin, as it did to Cézanne and to Van Gogh.

Pissarro was the key figure behind the scenes in the crisis years of 1882 and 1883, when Gauguin lost his job and became a full-time painter. The exact course of events which led to this decision cannot now be reconstructed. 1882 was a year of financial crisis in France, when bankruptcies abounded, and perhaps business was so bad that Gauguin optimistically thought he could earn a better living by selling his own pictures. He had good reason for feeling that painting was now too important to be only a part-time activity - had not Huysmans singled out his nude study for praise at the 1881 Impressionist exhibition? Had he not now won the support of Degas as well as of Pissarro? - Degas whose influence is so pronounced in the ambitious figure pictures that Gauguin did in 1881 (Plate 1)?

Gauguin's adroit practice of furthering his own artistic progress by taking what he needed from established contemporaries inevitably led to personal difficulties. In November 1883 he abandoned Paris as being too expensive for a full-time artist, and moved to Rouen. He wanted to be near Pissarro, with whom he had grown accustomed to working in summer vacations; but the many landscapes of 1884 show Gauguin more interested in Cézanne's work than in Pissarro's, and it must have saddened Pissarro to see his gifted pupil drifting away.

Cézanne for his part was (and always remained) deeply suspicious of Gauguin, whom he suspected of stealing his ideas. This is hardly surprising, when we consider for example Gauguin's remarks in a letter written late in 1881 to Pissaro: 'Has M. Cézanne found the exact formula for a work acceptable to everyone? If he discovers the prescription for compressing the intense expressions of all his sensation into a single and unique procedure, try to make him talk in his sleep by giving him one of those mysterious homeopathic drugs, and come immediately to Paris to share it with us.' Gauguin was passing through that natural stage in any major artist's development when he absorbs what is going on around him before making the decisive leap forward himself. But it is interesting to find in this half-serious comment to Pissarro the idea that there exists some kind of magical recipe for painting, if one could only discover it.

One can argue I think that Gauguin's ideas about what art should be were crystalizing faster than his ability to express them in paint on canvas. After a year in Rouen marked by intense activity and increasing financial problems, Gauguin left to join his wife in Copenhagen. Mette had sensibly decided that it was hopeless to expect her husband to support her and the five children by sales of paintings; the only solution was to return to her family in Denmark, where at least she could work as translator and French teacher. Gauguin followed, and was evidently thoroughly humiliated. In his isolation, he turned for the first time to paint himself (Plate 3). Gauguin also had time to think, and in a letter to his friend and former colleague Schuffenecker tried to find words to describe his new ideas. The appeal of painting, he says, must be total, must work through all the senses. A naturalistic approach, he implies, is not enough; colours, lines, repetition of shapes can in themselves communicate emotions to the beholder.

It was not immediately obvious to Gauguin how all this could be put into practice. On his return to France without Mette, in the summer of 1885, he continued to work hard, but was restless, moving from place to place. Constantly in financial difficulties, he briefly visited London as a courier for Spanish revolutionary friends. A curious consequence of this trip may be the *Still Life with Horse's Head* (Plate 6), which offers a programmatic union of Greek and

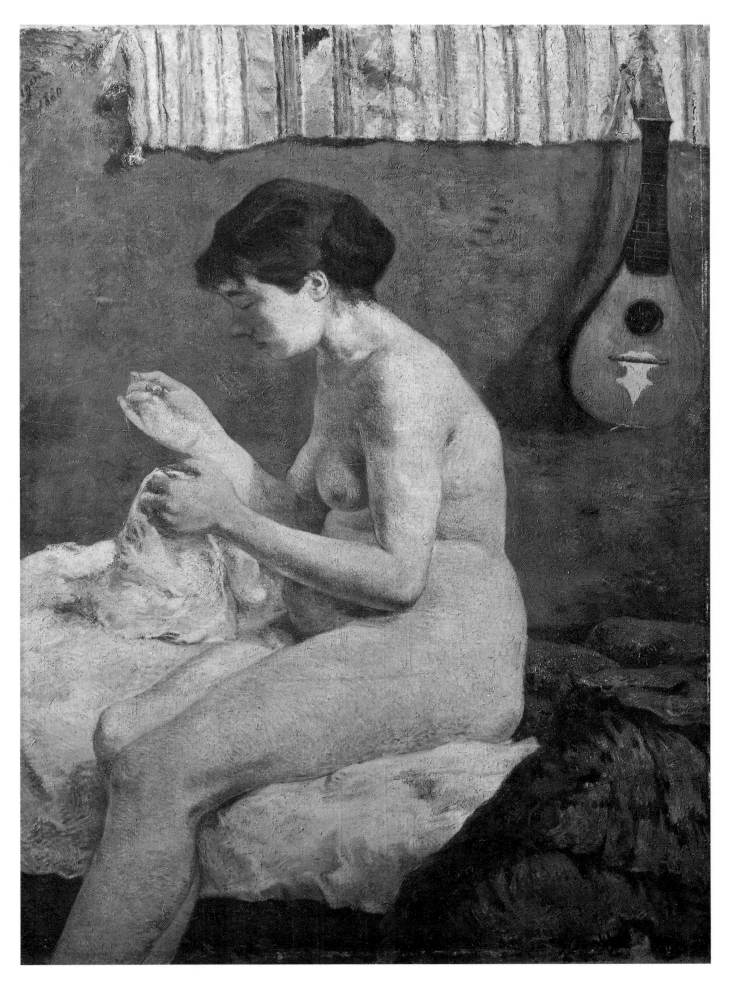

Japanese in its juxtaposition of the horse's head from the Elgin marbles against the Japanese hand puppet and fans. It has been argued that this picture is evidence of Gauguin's awareness of the closing exhortation of Whistler's *Ten o'clock lecture*: 'We have then but to wait - until, with the mark of the Gods upon him - there comes among us again the chosen - who shall continue what has gone before. Satisfied that, even were he never to appear, the story of the beautiful is already complete - hewn in the marbles of the Parthenon - and broidered, with the birds, upon the fan of Hokusai - at the foot of Fusi-yama.'

Whistler first delivered the lecture in London in February 1885, but repeated it in Dieppe later in the year at Daniel Halévy's house. It is just possible that Gauguin may have heard Whistler give the lecture: he was certainly in contact with Dieppe artistic circles in the late summer of 1885, and would have known something about Whistler's brilliant formulation of his artistic theories.

Whistler's *Ten o'clock* passage may well have aroused the latent messianic streak in Gauguin, who seems to have returned from Denmark determined to play the part of an artist with a message. The leadership of the avant-garde in 1885 was held decisively by Seurat, whose pseudo-scientific neo-Impressionism was quickly attracting disciples - including Signac and the now middle-aged Pissarro. Gauguin made some tentative experiments in this direction - the *Still Life with Horse's Head* is one - and became friendly with Signac. He could hardly have failed to be involved in the discussions around Seurat's *La Grande Jatte*, which was shown at the eighth and last Impressionist exhibition in May 1886. Seurat's masterpiece must have made Gauguin's own contribution to the exhibition - a dozen or so landscapes, and some still lifes and portraits - look very small beer by comparison.

There was no doubt a certain deep-rooted tension in the quarrel with Seurat that broke out at this moment. Gauguin said that he had Signac's permission to use his Paris studio for the summer: but Signac had left the key with Seurat, who claimed to know nothing about the offer and would not take Gauguin's word. Perhaps on an impulse after this rejection, Gauguin in June 1886 left Paris for Pont-Aven in Brittany.

It was not however a sudden decision: Gauguin had been thinking of going to Brittany for at least a year. It was the first decisive step towards the primitive environment that he had come to feel was necessary if his art was to develop. He had heard about Brittany from artists who had spent their summers there: it would be cheap, with congenial company, and an ideal place for a good summer's painting.

Gauguin stayed until November, painting better than before, but not yet having found himself as an artist. The subject matter was right, but not the treatment. The debts to the older Impressionists are still strong in such paintings as *Four Breton Women* (Plate 8) and *Two Girls Bathing* (Plate 11). Degas in particular is the major influence here; but in some of the landscapes it is Monet one thinks of; and in other works, like the *Still Life with Portrait of Laval* (Plate 9), it is Cézanne (Fig. 4). Gauguin was endlessly talking about finding a synthesis, but somehow it eluded him. Though he had a natural authority among the other painters at Pont-Aven, he was not yet flamboyant or over-confident. The Scots painter, A.S. Hartrick, gives us an excellent description of Gauguin's physical appearance at this time:

'Tall, dark-haired and swarthy of skin, heavy of eyelid and with handsome features all combined with a powerful figure . . . He dressed like a Breton fisherman in a blue jersey and wore a beret

Fig. 4
Landscape After
Cézanne
1885. Copenhagen, Ny
Carlsberg, Glyptotek

jauntily at the side of his head. His general appearance, walk and all, was rather that of a well-to-do Biscayan skipper of a coasting schooner - nothing could be further from madness or decadence. In manner he was self-contained and confident, silent and almost dour, though he could unbend and be quite charming when he liked.'

Gauguin needed this taciturn self-containment, for the next months of his life were hard indeed. He spent the winter in Paris, painting little but making extraordinarily inventive ceramics in the workshop of the potter, Chaplet. He was ill in hospital for a month, and now began to dream of leaving inhospitable France for a warmer climate. In April 1887 he embarked for Panama, where his sister's husband was working - for she, perhaps subject to the same romantic Peruvian dream that affected her brother, had married a South American business man. But Gauguin's idea of an easy life in the tropics had to meet the reality of poverty, illness and neglect; and even the comparative haven of the French island of Martinique soon became unbearable. Gauguin had to work his passage back to France as a deck-hand, bringing with him a dozen pictures (among them Plate 10) whose brighter colours and tapestry-like design show the first clear signs of a break with Impressionism.

Gauguin had little inclination now to stay in Paris, and in February 1888 left for Brittany again. Thus began the most decisive, most prolific, two-year period of his entire career. He was beginning to feel closer to that long sought synthesis that seemed to be the secret of painting. For the moment he was in the right surroundings. He told Schuffenecker: 'You're a Parisian, but give me the country. I love Brittany. I find wildness and primitiveness there. When my wooden shoes ring out on its granite soil, I hear the muffled, dull and powerful note I am looking for in my painting.'

Gauguin was finding out more about himself. Before leaving Paris he had written to Mette: 'You must remember that there are two natures in me: the Indian, and the sensitive man. The sensitive man has now disappeared, letting the Indian go ahead strong and straight.'

At first the 'Indian savage' was too ill to paint, and the weather was bad, but when spring came he began to work in earnest, finishing two and even three pictures a week. But they were not so very different from what he had done two years before, and it was not until Émile Bernard arrived early in August with some new paintings that Gauguin suddenly realized he could go much further in the direction he was already moving.

'Little Bernard', as Gauguin called him, was only 20, but he was a brilliant and precocious talent. He had just invented a new manner of painting that was promptly labelled *cloissonism*: this had given Bernard a certain standing in the Parisian avant-garde. Like many others, he was looking for a visual equivalent of the symbolist poetry and prose that was strongly emerging in reaction against naturalism. His idea was to express only the essence of any subject, with the simplest of means - a few thick, black lines, dividing flat, bright colours (Fig. 5).

Gauguin saw the point at once. On 14 August 1888, he wrote to Schuffenecker: 'A word of advice. Don't paint too much after nature. Art is an abstraction. Extract it from nature by dreaming in front of it, and think more of the creation which will result. The only way to reach God is to do what he does: create . . . My latest works are on the right track, and I think you'll find a personal touch, or rather that they confirm my earlier researches, the synthesis of a single form and single colour in which only the leading idea counts.'

Responding to Bernard's stimulus, Gauguin immediately went far beyond his young friend's ideas - and this is the essential nature of their relationship. Bernard painted *Breton Women in the Meadow*, showing peasants dressed for the Pardon of Pont-Aven, and introducing two ladies in city costume. Gauguin liked this picture so much, that he made an exchange with Bernard; and took it with him to Arles to show Vincent Van Gogh. But he had seen at once that the naturalistic subject matter was inadequate in itself, and must somehow be transcended. He wanted to 'invoke beautiful thoughts with form and colour', as he told Schuffenecker. The result was *The Vision After the Sermon* (Plate 12), Gauguin's first unquestioned masterpiece, and the turning point of his entire oeuvre.

Instead of simply painting Breton women, Gauguin tries to express in paint a *quality* that he admires - the simple faith that allows these peasant folk, when leaving church after a particularly vivid sermon, to have a vision of what has been described to them. He disposes of the women round two sides of his composition, rather as Bernard does, but he paints the green field red, and places on it the struggling figures of Jacob and the Angel, freely adapted from a Hokusai print of wrestlers, that he either owned or had copied. The idea of painting a religious subject probably came from Van Gogh, who in correspondence with Gauguin said that he had been trying unsuccessfully to paint a *Christ in the Garden of Olives*. Gauguin writes to tell Van Gogh of his own attempt: 'I believe I have attained in these figures a great rustic and superstitious simplicity. It is all very severe . . . To me in this painting the landscape and the struggle exist only in the imagination of the praying people, as a result of the sermon. That is why there is a contrast between these real people, and the struggle in this landscape which is not real and is out of proportion.'

Gauguin wanted to give the picture to a local church. That at Pont-Aven was modern, so with his friends he carried *The Vision after the Sermon* across the fields to the nearby village of Nizon. Among

the church's old stone piers and crude carved sculptures of saints the painting would be at home. He wrote in blue letters on the white frame: 'Gift of Tristan Moscoso'. It was a tribute from the Peruvian savage to primitive Brittany - but the curé, fearing a hoax, would not accept the gift, so the picture was removed.

The idea of remaining in Brittany for the cold, damp, winter months was unattractive, and in October Gauguin accepted the pressing invitation from Vincent Van Gogh to join him in Arles. He did so reluctantly, but out of an obligation to Vincent's brother, Theo, who was the first art dealer to give Gauguin the backing and support he needed. The story of the ten tumultuous weeks in Arles is well enough known, and there is every reason to feel that a temperamental incompatibility between the two men made the rupture inevitable. 'Vincent likes my paintings very much', Gauguin told Bernard, 'but when I do them he always finds faults. He is a romantic, but I am rather drawn towards the primitive.'

It is very clear - and psychologically convincing - that Gauguin saw himself as the master, and that Vincent gladly accepted the role of pupil. With all the fervour of the newly converted, Gauguin now knew what ought to be done. Don't paint from nature. Art is an abstraction. One must work from memory. All were precepts calculated to reduce Vincent to despair. But Gauguin took Vincent's subjects, such as the *Night Café*, and showed him how they should be

Fig. 5
Les misérables: Self-Portrait with a Portrait of Bernard
1888. Oil on canvas, 45 x 55 cm. Amsterdam, Stedelijk Museum

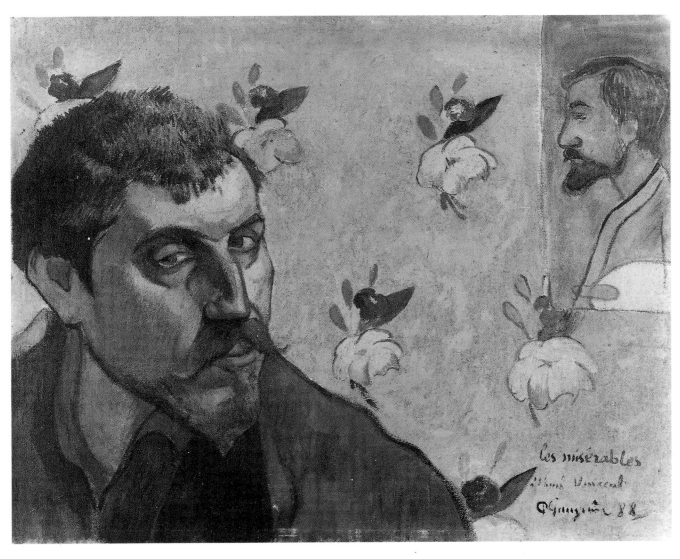

painted (Plate 15). Vincent had been working in the public garden at Arles. Let us meditate on this subject, one imagines Gauguin saying, what does it suggest to you? I am reminded of the women of Brittany (Plate 8), but don't you think of your mother and sister, as they used to walk in the garden of your father's house at Etten before you left Holland? You must introduce them into your picture - and this Vincent dutifully did in his painting, *Women in the Garden (Souvenir of Etten)*.

Gauguin thought that his most successful picture at Arles was the one in which he painted Breton women in an Arles vineyard - 'so much the worse for accuracy'. He called it *Human Anguish* (Plate 17), and the title is an indication of what he wanted art to express. To be obsessed with the depiction of the visible world, as Vincent was, was to remain enslaved to naturalism, and Gauguin wanted his art to be above all poetic and mysterious.

Vincent , for his part, couldn't follow where Gauguin led (Fig. 6). 'I can't work without a model.' Weeks later, when his dream of the atelier in the South had collapsed, Vincent was to write to Émile Bernard: 'When Gauguin was in Arles, as you know I once or twice allowed myself to be led to abstractions. At the time, this road to the abstract seemed to me a charming track. But it's an enchanted land, my dear friend, and soon one finds oneself up against an insurmountable wall.'

An 'enchanted land' however was just what Gauguin sought in his own art.

Gauguin wasn't able to paint much in Paris. He made pots, and lithographs on zinc of earlier subjects. It was the year of the Universal Exhibition of 1889: the Eiffel Tower was being erected, and in artistic circles there was much discussion of the art shows. Excluded from the official exhibition, Gauguin and his friends got permission to hang their pictures in the Café des Arts. They called themselves the *Impressionist and Synthetist Group*. Their work made little impact on the public: but among the painters it confirmed Gauguin's position at the head of a new movement, now challenging the avant-garde primacy of Seurat's neo-Impressionism.

Gauguin was more interested in the Universal Exhibition itself, and especially the colonial section, with its reconstructions of the temple of Angkor-Wat and of a Javanese village, complete with native huts and dancing girls. He was collecting photographs of Buddhist and especially of Cambodian art: at this time he was thinking of going to Tonkin in French Indo-China, and had begun to negotiate with the French Colonial Office. This took time, and while waiting Gauguin decided to go back to Brittany.

He spent most of the summer at Pont-Aven, but the village was now becoming too crowded, too civilized for his tastes. In October Gauguin moved with his disciples and supporters, Meyer de Haan and Paul Sérusier, to the remote hamlet of Le Pouldu, where they settled at the inn of Marie Henry (Figs. 7 and 8). She became Meyer de Haan's mistress, and complaisantly allowed the painters to decorate the living room as they wished. On the doors of a wooden cupboard, Gauguin painted caricature portraits of Meyer de Haan and of himself (Plate 24). Above the *Caribbean Woman* (Plate 23) on the entrance doorway, he made another version of *Bonjour M. Gauguin*. These are frankly decorative pictures, and Gauguin is free of naturalistic constraints: he adopts highly stylized forms, simplified colours and he deliberately keeps the surfaces very flat.

Bonjour M. Gauguin (Plate 19) was an explicit homage to Courbet, whose painting *Bonjour M. Courbet* Gauguin had seen when he

visited Montpellier with Van Gogh. It is sometimes presumed that Gauguin is mocking Courbet's pretensions, but there is no evidence whatsoever for believing this. On the contrary, it would appear that Gauguin appreciated that Courbet's placing of himself at the centre of his painting was not simply arrogant egotism but artistic necessity. It represented a basic shift in the nature of nineteenth-century painting, as the artist gradually removed subject matter from a public domain to a private one.

Following Courbet's example, Gauguin proceeds to make it clear that, whatever he is ostensibly painting, his art is firmly centred on himself. In the caricature self-portrait (Plate 24) he gives himself a halo, but the apples and serpent indicate that this is Gauguin as Lucifer, the devil himself. Not content with a fashionable Satanism, Gauguin also presents himself as Christ. The triptych of religious paintings executed in the autumn of 1889 - the *Agony in the Garden*, the *Crucifixion* and the *Deposition* - use the symbolic Christian events, but to entirely personal ends. Gauguin was not a Christian, and unlike his friend Bernard he had no desire to revive religious painting. If he had painted *The Vision after the Sermon*, it was because he admired the simple faith of the Breton women, so strong that it could inspire vision. With both the *Crucifixion*, or *Yellow Christ* (Plate 20) and the *Deposition*, or *Green Christ* (Plate 21) Gauguin takes a local carving - the polychrome wooden crucifix from Trémalo, and the stone Calvary of Nizon - and reinterprets it against a local landscape background - Pont-Aven for the *Crucifixion*, Le Pouldu for the *Deposition*. In the *Crucifixion* appear the Breton women from *The*

Fig. 6
Vincent Van Gogh
The Starry Night
1889. Oil on canvas,
73.7 x 91.4 cm. New York,
Museum of Modern Art

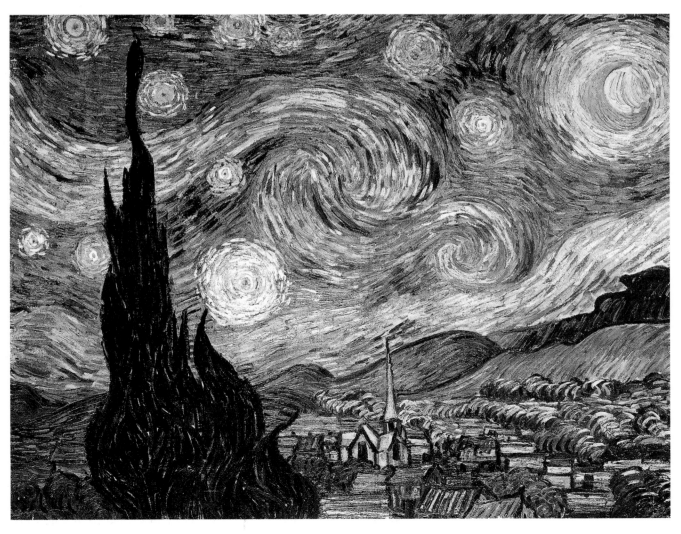

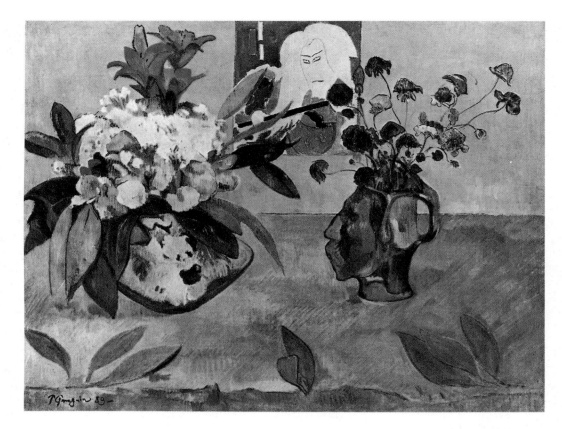

Fig. 7
Still Life with
Japanese Print
1889. Oil on canvas,
73 x 92 cm. New York,
Ittleson Collection

Fig. 9 (opposite)
'Soyez amoureuses
vous serez heureuses'
1889. Painted wood,
97 x 75 cm. Boston,
Museum of Fine Arts

Fig. 8
Cup in the Form of a
Self-Portrait
Glazed Stoneware

Vision after the Sermon, as if to stress the connection with the earlier painting.

Gauguin gave the young critic Albert Aurier some cryptic notes about the *Green Christ*, which seem to suggest that he could appreciate what religious belief meant for the Breton, and yet could see no way in which he could share it. This surely is the meaning of *Bonjour M. Gauguin*, where the gate bars the heavily-shrouded painter from any real contact with the Breton peasant. Gauguin's isolation is dramatically emphasized by the storm clouds in the sky: he appears as a symbol of the loneliness and suffering that he had come to feel was the lot of the dedicated artist. It is not surprising that in the three religious paintings, Gauguin gradually edges towards the identification of himself with Christ. In the *Agony in the Garden*, or *Christ in the Garden of Olives* (Plate 22), probably the last of the three to be painted, the features of Christ are clearly Gauguin's own: there exists also a self-portrait which juxtaposes Gauguin's head with that of the Christ in the *Crucifixion*, and another later *Self-Portrait* which Gauguin inscribed 'Près de Golgotha'.

In such works, Gauguin does not seem to have been deliberately blasphemous. His own beliefs were profoundly influenced by the ideas of Schopenhauer, whose philosophy was popular in advanced intellectual circles in France at the time. There is no evidence that Gauguin actually read the work of the German philosopher, but he had come to share his pessimism and his preference for Buddhism over Christianity. He was also inclined to believe in the power of the will as the only way in which the nothingness of existence can be transcended, and to share Schopenhauer's conviction that the very exercise of the will is evil. A small portrait of Meyer de Haan painted late in 1889 has the word *Nirvana* written on it, as if to indicate the common aspiration of the two painters, and the majestic carved relief made by Gauguin at this time carries a message in its inscribed title:

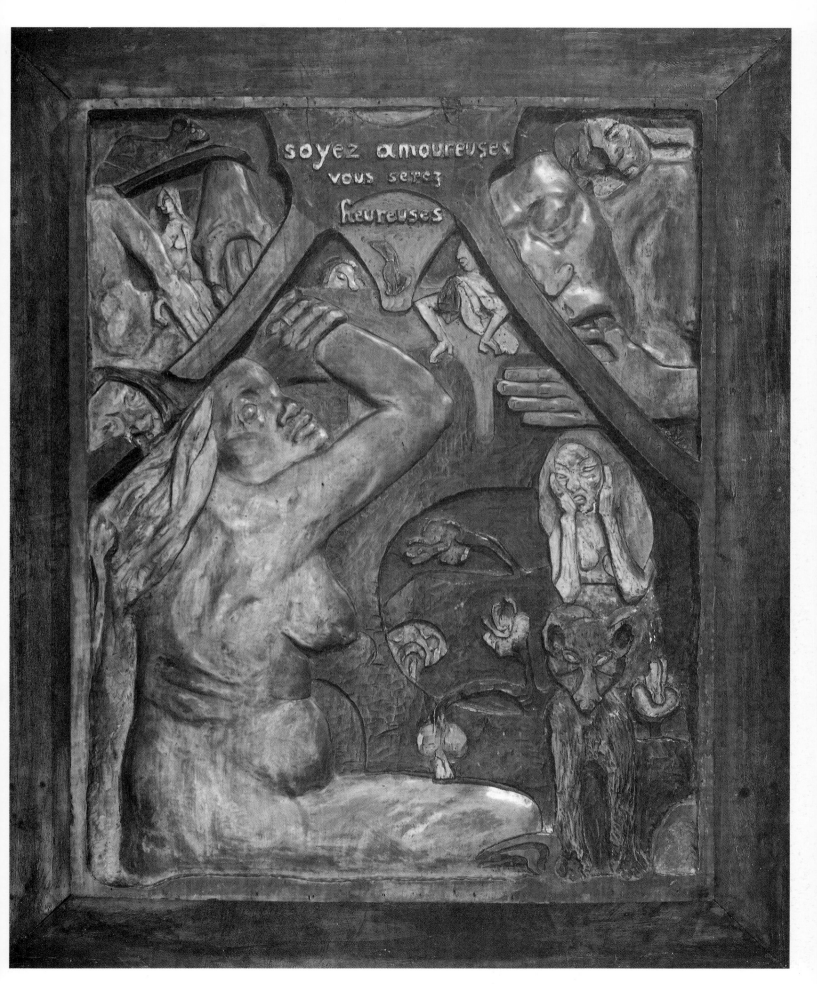

Soyez amoureuses vous serez hereuses (Be loving you will be happy; Fig. 9).

In a few words it is impossible to do justice to the complexity of Gauguin's thinking. That thinking is in any case expressed primarily through the medium of the painting and the sculpture. Leaving naturalism behind, Gauguin now began to experiment with type-figures, which reappear from painting to painting, carrying with them a symbolic content. The seated nude woman with hands to her face in the background of Nirvana, for example, reappears in contemporary paintings as a Breton Eve, and again later in Gauguin's last testament, *Where Do We Come From? What Are We? Where Are We Going?* (Plate 44). One cannot interpret such type-figures in precise verbal terms, and this is an important characteristic of Gauguin's symbolism: there must always remain that vestigial sense of poetry, of mystery, of something too near the heart of things to be easily explicable.

Gauguin's problem in 1889-90 was to find the kind of subject that could carry the message of his painting. He had quickly exhausted the possibilities of Christian iconography, and though he concurrently painted a long series of Breton subjects, these were not altogether successful. *The Seaweed Harvesters* (Plate 25) is the largest canvas of this period, yet it remains comparatively unknown; the *Breton Girls by the Sea* (Plate 18) seems to hint at a significance greater than the ostensible subject, but without altogether convincing us. If we compare it with *The Loss of Virginity* (Plate 27) we can appreciate what it was that Gauguin wanted to express.

A young girl lies naked in a landscape: her feet are crossed, like those of the *Yellow Christ*; one hand holds a flower, the other rests on the fox. He sits on her shoulder, with a paw on her heart, and is presumably the very same animal who had appeared in the carved relief *Be Loving*, when Gauguin described him as the Indian symbol of perversity. Here he seems to represent lubricity and sexual desire as well. Behind the girl is a line of flame-like foliage that isolates her, like a Brunnhilde awaiting Siegfried on the rocky mountain. In the distance, a Breton landscape with a procession of figures and on the horizon the sea. The title, *The Loss of Virginity*, makes the meaning of the picture obvious - too obvious perhaps, because the painting is exceptional in Gauguin's oeuvre for the explicit nature of its symbolism. It might have been a demonstration piece: for *The Loss of Virginity* was probably completed in Paris in the last months of 1890, when Gauguin's contacts with symbolist literary figures were at their closest (Fig. 10). Verlaine, Moréas, Morice, Barrès, Mallarmé became his friends, and Gauguin was now regarded in advanced circles as the outstanding painter of his generation. Public success, and a life free from material cares, were certainly within his grasp: the dream of a reconciliation with his wife and children could well have become a reality. Yet Gauguin wilfully rejected this because of the daemon that now drove him, in April 1981, to leave France for Tahiti.

Gauguin had been dreaming of going back to the tropics ever since his return from Martinique. As we have seen, after visiting the 1889 Exhibition he thought of going as a settler to Tonkin in French Indo-China. As he told Émile Bernard in June 1890: 'The whole Orient, great thoughts written in letters of gold on all the art - that is certainly worth study, and I'm sure I shall acquire new strength there. The West is rotten at this moment, and any young Hercules can, like Antaeus, find new strength by setting foot on that soil. You'd come back, a year or two later, sound and strong.'

At this moment Bernard read Pierre Loti's semi-autobiographical novel, *The Marriage of Loti*, first published under the Tahitian title

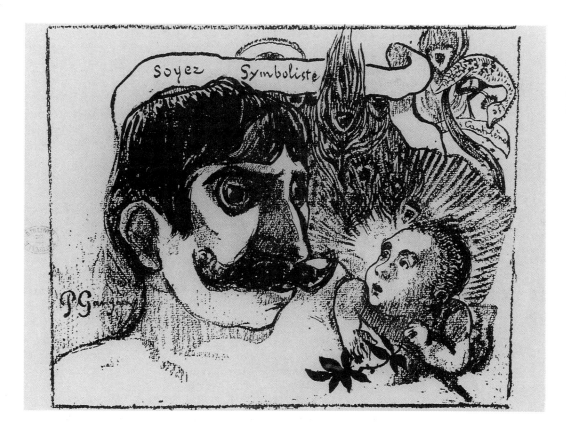

Fig. 10
'Soyez symboliste'
(caricature portrait
with Jean Moréas).
c. 1891. 34 x 40 cm. Paris,
Bibliothèque Nationale

Rarahu in 1880. Loti was a former naval officer, of the same age as Gauguin, who knew and admired his novels - *Icelandic Fishermen* of 1886, for example, which inspired Van Gogh's *Berceuse* paintings. Bernard sent *The Marriage of Loti* to Gauguin, and with it the official handbook to the French colonies, which had an enthusiastic essay on Tahiti. Gauguin hesitated no longer: it was to Tahiti that he would go. He succeeded in getting official permission to travel as an artist on an unpaid mission. This gave him status and certain financial advantages, although the verbal promise of purchase of pictures on his return was never kept.

Just before leaving, Gauguin paid a short visit to Copenhagen to see his wife and children. He had still not abandoned the idea of a reconciliation, although, apart from his 17-year-old daughter, Aline, he now found his family strangely alien to him. But Charles Morice records that Gauguin broke down on returning from Denmark, when he tearfully confessed to having sacrificed his family to his ideas.

Gauguin sailed from Marseilles on 1 April 1891, and arrived at Papeete, the capital of Tahiti, on 9 June. Three days later, hours before Gauguin's appointment to meet him, Pomare V, the last king of Tahiti, died. It was a bad augury. Gauguin was soon to realize that he had come to a down-at-heel French colony, and not to an island paradise untouched by Western civilization. He was in fact over a hundred years too late. Since the island's discovery by the West in 1767, the native population had fallen catastrophically from an estimated 150,000 to about 8,000, and virtually nothing now remained of the traditional religion, mythology and art.

After a few months Gauguin moved out of the unattractive little capital to the village of Mataiea on the beautiful south coast of the island, about 80 miles away. He had got to know the Francophile local chief, Tetuanui, and this seemed to offer a way of at least coming closer to native life. But Gauguin had no illusions about Tahiti: very soon after his arrival he was already seeking an appointment in the Marquesas Islands, another French possession.

Gauguin's attempts to move away from Tahiti into a more

primitive environment were frustrated by the Governor, Lacascade, who saw in him a potential trouble maker. Bouts of illness, resulting from the syphilis that was eventually to kill him, and constant financial difficulties, were troubling Gauguin, and by June 1892 he was asking for repatriation to France. This was agreed in November, but Lacascade regretted that no funds for a passage were then available, and Gauguin had to wait until 14 June 1893 before he could leave. His first stay in Tahiti had lasted almost exactly two years.

Despite all the disappointments and discouragements, it was, after a slow beginning, a most rich and prolific time for his painting. Gauguin completed about 80 pictures, 30 of them by any reckoning masterpieces, and this is as many as he was to produce in the remaining ten years of his life. At first he was accustoming himself to the new surroundings, and in subject matter the pictures are a continuation of the kind of work he had been doing in Brittany - some landscapes, but mostly pictures of the local people at work and at play. For three or four months after settling in Mataiea in October 1891, Gauguin seems to have been completely happy, and this is reflected in his work. At Christmas he painted the idyllic *Ia Orana Maria* (Plate 31) - the title is the first part of the Tahitian version of the Ave Maria - and the picture shows an angel with yellow wings pointing out to two Tahitian women the figures of Mary and Jesus. They are seen as Tahitians, just as the crucified Christ and the mourning women had been depicted as Bretons. *Ia Orana Maria* is the direct successor to the earlier religious paintings, and the changed mood reflects Gauguin's new-found and short-lived happiness in Tahiti.

Other Tahitian pictures of 1891-2 can be closely linked with earlier work. *Reverie* (Plate 29) evokes a distinct mood, as does *The Loss of Virginity; Ta Matete* (Plate 34) is a painting of prostitutes waiting for customers, like the Arles *Night Café* (Plate 14). One can also compare *When Will You Marry?* (Plate 32) to the *Breton Girls by the Sea* (Plate 18); or the *Woman with a Flower* (Plate 28) - the first of Gauguin's Tahitian paintings to be exhibited in Paris - to earlier portrait studies. But there is also a new strangeness about the paintings. Probably none were done direct from nature: Gauguin continued to work from memory in his studio, and certain elements and stock figures reappear from picture to picture. He was also introducing frankly exotic references into his compositions. As he later told de Monfried: 'Have always before you the Persians, the *Cambodians*, and a little of the Egyptians. The great error is the Greek, however beautiful it may be.' This explains the conscious and deliberate borrowings from Khmer art, for example, in the poses of the two Tahitian women in *Ia Orana Maria* which are taken directly from a photograph Gauguin had of part of the frieze of the Javanese temple of Borobudur; also the use of Egyptian reliefs, allegedly seen in the British Museum, for the women on the bench in *Ta Matete*.

No doubt Gauguin would have also introduced motifs from Tahitian art, had there been anything to introduce. All that was left locally were the traditional colours and patterns of the *pareos* - the loose-fitting dresses worn by the women. Gauguin liked them, because they accorded well with the tendency of his more considered pictures at this time to be very flat and abstract in conception - for example, *Near the Sea* (Plate 35) and the large *Pastorales Tahitiennes* (Plate 36). Gauguin was particularly pleased with the latter, a larger version of the painting now in the Louvre which he called *Joyeusetés* (fun or amusement). He was beginning to

feel able to express his vision of Tahitian existence in an artistically convincing way.

That it was a vision of existence and not a copy of the real thing should always be borne in mind. For Gauguin was now reconstructing in his own paintings the perfect life which he had failed to find in reality. On a visit to Papeete in March 1892 he had been lent a book about Tahiti before the Europeans had arrived which, though full of false interpretations, was nevertheless to stimulate his imagination and enrich his painting. This was J.A. Moerenhout's *Voyage aux îles du grand océan*, published in 1837, when the disintegration of Tahitian society was already well under way.

Moerenhout's book was full of Tahitian legend and history, and Gauguin was fascinated by the accounts of the long vanished Arioi, a priestly élite whose communion services were sexual as well as religious. He painted the Arioi's legendary beauty, Vairaumati; and he painted the moon goddess Hina (Plate 38), the only Tahitian female divinity, and the ancestral mother of the gods and the human race. As the Tahitians never made any idols, Gauguin had to invent one, mixing hints of Buddha, Pharaoh and Easter Island statue to make a satisfactory image.

Recent research, by Bengt Danielsson in particular, has given us a much clearer idea of the relationship between the actuality of Gauguin's Tahitian existence, and the pictures that he painted. This can only make us respect still more Gauguin's courage and his imagination. His own account of his life, *Noa-Noa*, blends fact with fiction, but there is no reason to expect veracity from an artist whose whole existence was now being lived out on the edge of dream.

Not that Gauguin did not also have his moments of happiness and tranquility, as the paintings themselves show. Cruelty and ugliness is banished from them, though fear and a sense of awe and mystery are sometimes present. When he took a native bride in the thirteen-year-old Tehamana (the Tehura of *Noa-Noa*), Gauguin found a new depth of inspiration. He knew that *Manao Tupapau* (Plate 33) was a masterpiece, and often wrote about it. The initial inspiration was Gauguin's return home one night to find Tehamana lying face down on her bed, gripped with terror at the darkness. She seemed to Gauguin both very beautiful, but also very foreign, looking at him as if he were the *tupapau* - the demon that lies in wait during sleepless nights. Gauguin began to think about man's fear of darkness and of death - and this is what his picture is about. He wrote of the picture: 'Let us sum it up. Musical part: undulating horizontal lines; blue and orange harmonies, linked with yellows and purples (their derivatives) and lit by greenish sparks. Literary part: the spirit of a living soul united with the spirit of the dead. Night and Day.'

Thus the painter's idea is conveyed directly through abstract means as well as by literary connotations. This is pictorial symbolism of a very high order.

Gauguin arrived back in Paris on 1 September 1893: as might have been expected at this time of year, all his friends were still out of town. It was an inauspicious beginning and Gauguin had now lived too long in Tahiti to feel at home in what was then the most civilized city in the world. He had lost contact with people, and could never recapture that feeling of being at the hub of all advanced creative activity which had been his in 1890-91. In any case the mood of Paris had changed: a reaction against experiment in the arts was setting in, and was to last for a decade. The anarchist bomb attacks, the Panama scandal, the Dreyfus case were all indicative of a general atmosphere of unease.

No doubt through the faithful Degas's good offices, Gauguin had

an opportunity of showing 44 of the best Tahitian pictures at the prestigious gallery of Durand-Ruel. Public reaction was generally antipathetic: there were some lukewarm reviews, and a few sales, mostly to old friends. Gauguin was disappointed: nobody seemed to understand what he was getting at. He was too dejected to do much painting, and welcomed Charles Morice's suggestion that they should collaborate on a book about Tahiti - this was to be entitled *Noa-Noa*, the Fragrant Isle. They worked together over Gauguin's notes, Morice preparing a draft text and Gauguin making woodcuts to illustrate it.

In the summer of 1894 Gauguin returned to Pont-Aven, but the spirit of the place that had once meant so much now eluded him. There is a curiously detached quality about the *Drame au Village* (Chicago, Art Institute), and this is perhaps confirmed by the fact that nobody is quite certain whether it was in fact painted during this summer. In the foreground is that same seated woman with hands to her face who first appeared in *Human Anguish* (Plate 17): we have already noticed her nude counterpart in *Nirvana* and *Where Do We Come From?* (Plate 44). And the problems of human communication that the *Drame au Village* seems to raise were now becoming increasingly real for Gauguin. Contemporaries speak of him as being aloof, taciturn, arrogantly self-confident - rather different from the convivial and gregarious artist of earlier years. Experience of living virtually alone for long periods now made Gauguin turn in on himself, hardening his heart against human feelings. Relations with Mette were worsening; and his former mistress Juliette Huet broke with Gauguin completely because of his infatuation with the thirteen-year-old Annah, the so-called Javanese - she was in fact half Indian and half Malay. When he painted Annah, however (Plate 40), Gauguin wrote on the picture a Tahitian sentence meaning 'The child-woman Judith is not yet breached' - a scabrous reference to another nymphet, the Swedish twelve-year-old Judith Erikson-Molard, whose company Gauguin liked to keep.

The details of Gauguin's life at this time have a sordid, distasteful quality, as if to prove the rotten, degenerate nature of life in the West. That he was suffering increasingly from the wide-spread effects of syphilis is now clear to us: whether Gauguin appreciated this is less evident. He was anxious to be off again: he wrote in September 1894 to Judith's stepfather, William Molard: 'I have taken the irrevocable decision . . . Nothing will stop me going, and it will be for good. How stupid an existence European life is.' Again there was an auction sale of paintings to raise money, Gauguin using as a preface Strindberg's letter declining the invitation to write it. The sale in February 1895 was disappointing but not disastrous. Gauguin was ready to go. It was only the need for more hospital treatment that made him postpone his departure from Paris until the end of June.

Gauguin arrived at Papeete on 8 September 1895, but this time he had no intention of staying on Tahiti: he was going to go on directly to Dominique in the Marquesas. We do not know why he changed his plans; it was probably because his health was deteriorating, and he knew he could only get hospital treatment if he stayed within reach of Papeete. He decided to have a native house built at Punaauia, on the coast about 20 miles south of the capital, and this remained his home until he finally left Tahiti in 1901. Tehamana was summoned but, frightened by Gauguin's running sores, she refused to stay with him. Another 14-year-old, Pahura, took her place.

Gauguin's life was a mixture of tranquility and relative contentment, when the painting went well, and appalling suffering, both mental and physical, when he could do nothing at all. The flat, bright colours of 1892-4 give way to a grave and sonorous tonality. *Nevermore* (Plate 43) is characteristic. Gauguin wrote of it to his friend and loyal correspondent, Daniel de Monfried:

'I wanted to suggest with a simple nude a certain barbarian luxury of times past. The whole is suffused in colours which are deliberately sombre and sad. It is neither silk, nor velvet, nor batiste, nor gold which makes this luxury, but simply matter which has been enriched by the artist's hand. No nonsense - man's imagination alone has enriched the dwelling with his fantasy.

'As a title, *Nevermore* (in English): not the raven of Edgar Poe, but the bird of the devil that is keeping watch. It's badly painted (I'm so on edge and can only work in bouts), but no matter, I think it's a good picture.'

The letter was written on 14 February 1897; as the year went on disaster followed disaster. Gauguin's landlord dies, and he has to move house. He learns of the death from pneumonia of his favourite child, Aline, and this leads to the final rupture with Mette. He is penniless, unable to walk because his foot is so painful, unable to paint because of conjunctivitis. In August he writes to Molard: 'Since my childhood, misfortune has dogged me. Never a chance, never any happiness. Everything always against me, and I cry out: Oh God, if you exist, I accuse you of injustice, of malice. Yes, on hearing of poor Aline's death, I doubted everything, I laughed in defiance. What use is virtue, hard work, courage, intelligence? Only crime is logical and makes any sense.' In September he is in despair. 'I can see nothing except Death which delivers us from everything.' In October a succession of heart attacks leads Gauguin to talk of suicide. For six months he has painted nothing: now he makes a final heroic effort. 'I wanted before dying to paint a big picture which I had in my head', he told de Monfried, 'and for a month I worked night and day in an unheard-of fever'.

The result was Gauguin's largest and most ambitious picture, on which he wrote the words: *Where Do We Come From? What Are We? Where Are We Going?* (Plate 44). Thus it is intended as a philosophical statement about the meaning of life, though before trying to explain it we do well to heed Gauguin's own warning: 'My dream is intangible, it implies no allegory. To quote Mallarmé: "a musical poem, it needs no libretto". As it is above the material, the essence of a work lies precisely in "What is not expressed" . . .'

Yet Gauguin also wrote more explicitly about the painting, and his reticence cannot conceal its obvious lesson. It was a dream, he said, painted out of his head - and it is peopled with figures who have appeared in many earlier pictures. It is full of animals, children and child-like 'savages', who live out their lives in a garden of Eden. Yet it is no innocent, virginal world, but one imbued with a latent eroticism. Every gesture, every symbol, almost every form proposes a sexual meaning; it is a dream of infantile sexuality that confronts us, as though Gauguin was here at last back in that warm, dimly-remembered, lost paradise of early childhood.

The central figure is a man plucking fruit from a tree, and we know what that implies. But it cannot be innocence that is lost; it is the thirst for knowledge, for awareness for anything beyond a crass acceptance of physical existence that marks the undoing of man. Many years before, Gauguin had seen his destiny plainly when he wrote to Schuffenecker: 'According to legend, the Inca came straight from the sun, and I shall return there . . . Vincent sometimes calls me

the man who came from far and will go far. I hope I shall be followed by all those good people who have loved and understood me. A better world is coming, where nature will follow its course; man will live in the sun, and know how to love.'

But by the time he had come to paint *Where Do We Come From?* Gauguin had lost his earlier optimism. Love has its dark side too: Eros is compounded with Thanatos, and the golden age is also an age when life is little more than bare survival from birth to death. All human endeavour he came to see as futile, as likely to result in evil as in good. 'Before us there is certainly only nothingness' - the words are Schopenhauer's but could equally well be Gauguin's. The only possible response was the private one proposed by the one man constantly in Gauguin's thoughts: the poet Mallarmé - one could create a work of art. And in *Where Do We Come From?* Gauguin speaks as one who knows and has seen all: this is the final message that he wants to leave behind for perpetuity.

Gauguin's suicide attempt failed - he took too much arsenic, and instead of being poisoned was miserably sick. Gauguin accepted this last trick of fate and did not try again, but the final years of his life are a kind of code to what has gone before. Dying of syphilis, he was living on borrowed time, and though he eventually got to the Marquesas and a little closer to the 'heart of savage darkness' that he sought, it was too late to make any substantial difference to his life or to his art.

For long periods in the last five years - he died on 8 May 1903 - Gauguin did no painting at all. His time was fully taken up working as a draughtsman in the office of Public Works at Papeete, or as a journalist active in local politics. It is a destiny that inevitably reminds one of Rimbaud's life as a trader in Abyssinia - both men had taken art too far and suffered for it.

But unlike Rimbaud, Gauguin never completely abandoned his art: indeed 1902 is a comparatively prolific year, and the strange and vivid colours of the Marquesan paintings introduce a new note into his painting. *L'Appel* and *Contes Barbares* (Plate 48) are among Gauguin's greatest paintings: there is a certain radiant tranquillity about them as though Gauguin had reached an understanding of his fate.

Three years after Gauguin's death an enormous exhibition of his work opened at the Salon d'Automne in Paris. It was one of the most influential art exhibitions ever held and directly from it much of the art of the twentieth century has sprung. In this respect Gauguin's only rival is Cézanne - a greater painter, as he would always have agreed, but Gauguin's influence has probably been more profound and wide-ranging.

For Gauguin transcends both the symbolism and the impressionism of the late nineteenth century. With him ends the pursuit of appearances, the obsession with the experience of perception that for so long had dominated European art. He rejected the painting of the Impressionists because 'they seek around the eye and not at the mysterious centre of thought.'

So art turns inwards, away from appearances. Towards dream and the unconscious towards an abstract art where colour and form alone convey the painting's meaning. To make this breakthrough somebody had to turn to the primitive as a means of liberating art from the great classical - Renaissance - naturalist tradition. Gauguin was not against this tradition - in certain respects his own painting embodies it - but he thought that it, like Western tradition as a whole, had come to an end. And he turned the private psychological

necessity which provided the driving force for his whole career into a means regenerating European art. Regression for the man meant primitivism for the painter.

In one of his last letters to de Monfried Gauguin wrote: 'You have known for a long time what I wanted to establish: the *right* to dare everything. My capacities . . . have not led to any great result, but at least the machine is in motion. The public owes me nothing, since my pictorial work is only relatively good, but the painters who, today, are profiting from this freedom, do owe me something.'

Gauguin was for once over-modest, but his clear-sighted honesty is appealing. As he had said in 1898, 'the martyr is often necessary for a revolution. My work has little importance compared to its consequences: the freeing of painting from all restrictions.' After Gauguin, everything was possible.

Outline Biography

1848 Eugène Henri Paul Gauguin born 7 June in Paris.

1849 His family leaves for Peru and his father dies at sea. He lives in Lima with his mother Aline and his sister Marie at the house of a relative.

1853 The family returns to live in Orleans.

1861 The family moves to Paris where Gauguin's mother works as a dressmaker. She meets the financier Gustave Arosa.

1865 Joins the merchant navy.

1867 Gauguin's mother dies while he is at sea.

1872 Is hired as a stockbroker by Paul Bertin. Begins painting around this time, studying with Emile Schuffenecker at the Académie Colarossi. Meets Mette Gad.

1873 Marries Mette Gad 22 November.

1874 Birth of Emil Gauguin 31 August.

1876 Exhibits a landscape at the Salon. Stops working for Bertin. Birth of Aline Gauguin 24 December.

1879 Invited to participate at the fourth Impressionist exhibition by Degas and Pissarro. Birth of Clovis Gauguin 10 May.

1880 Exhibits eight works at the fifth Impressionist exhibition. Works for the insurance broker Thomereau.

1881 The dealer Durand-Ruel buys three of his paintings. Exhibits at the sixth Impressionist exhibition. Birth of Jean-René Gauguin 12 April.

1882 Exhibits at the seventh Impressionist exhibition.

1883 Loses his job as a result of the stock market collapse. Birth of Paul (Pola) Rollon Gauguin 6 December.

1884 Family moves to Rouen. July: Mette returns to Denmark with Aline and Pola. November: goes to Copenhagen to join family.

1885 May: exhibits at the Society of the Friends of Art in Copenhagen. June: Returns to Paris with Clovis. In the early autumn goes to London.

1886 Exhibits at the eighth Impressionist exhibition. July: goes to Pont-Aven in Brittany. Meets Charles Laval and Emile Bernard. October: returns to Paris.

1887 April: goes to Panama with Laval. June: goes to Martinique. November: arrives back in France. His works are admired by Vincent and Theo Van Gogh.

1888 Theo Van Gogh buys three of his paintings. Returns to Pont-Aven. Works with Emile Bernard and Serusier. October: goes to Arles to work with Van Gogh. December: leaves Arles for Paris.

1889 February: returns to Pont-Aven. June-October: *Exhibition of paintings by the Impressionist and Synthetist Group* is held at the Café Volpini during the Exposition Universelle. June: moves to Le Pouldu in Brittany.

1890 In Paris until June when he returns to Le Pouldu. November: in Paris where he mixes with symbolist writers.

1891 February: his works sold at the Hôtel Drouot. March: in Copenhagen where he sees his family for the last time. March 23: banquet held in his honour at the Café Voltaire, to celebrate his departure for Tahiti. Arrives in Papeete 9 June. September: moves to Mataiea, where he meets Tehamana.

1892 Reads J.A. Moerenhout's *Voyage aux Iles du Grand Océan*. March: the first Tahitian works exhibited at Goupil's gallery in Paris.

1893 Arrives back in Paris. November: exhibits 41 Tahitian pictures at Durand-Ruel's. Collaborates with Charles Morice on *Noa Noa*.

1894 Lives with Annah the Javanese. Returns to Pont Aven in the spring.

1895 February: exhibition of pictures and sale of his work at Hôtel Drouot to raise funds. July: leaves for Tahiti where he arrives on 9 September. November: builds a native hut in Punaauia.

1896 Takes Pahura as his *vahine*. They have a daughter who dies shortly after birth.

1897 Learns of death of his daughter Aline. Final break with his family.

1898 November: exhibits *Where Do We Come From?* at Vollard's. April: Pahura gives birth to Emile.

1901 September: arrives on Hivaoa in the Marquesas. Begins to build his `House of Pleasure'. Takes Vaeoho as his *vahine* and their daughter Tahiatikaomata is born 14 September.

1903 Dies 8 May.

Select Bibliography

Catalogues Raisonnés

Bodelsen, Merete, *Gauguin's Ceramics: a Study in the Development of his Art*, London, 1964.
Wildenstein, Georges, *Gauguin*, vol.1, Paris, 1964.

Monographs

Andersen, Wayne V., *Gauguin's Paradise Lost*, New York, 1971.
Danielsson, Bengt, *Gauguin in the South Seas*, London, 1965.
Goldwater, Robert, *Symbolism*, New York, 1979.
Malingue, Maurice, *Paul Gauguin: Letters to his Wife and Friends*, London, 1946.
Merlhès, Victor (ed.), *Correspondance de Paul Gauguin, 1873-1888*, Paris, 1984.
Rewald, John, *Gauguin*, Paris, 1938.
 Gauguin Drawings, New York, 1958.
 The History of Impressionism, 4th rev. ed. New York, 1973.
 Post-Impressionism from Van Gogh to Gauguin, 3rd rev. ed. New York, 1978.
Roskill, Mark, *Van Gogh, Gauguin and the Impressionist Circle*, London, 1970.
Stevenson, Lesley, *Gauguin*, London, 1990.

Thomson, Belinda, *Gauguin*, London, 1987.
Wadley, Nicholas (ed.), *Noa Noa: Gauguin's Tahiti*, Oxford, 1985.

Periodical Articles

Bodelsen, Merete, 'Gauguin's Cézannes', *Burlington Magazine*, 104, no.710.
'Gauguin the Collector', *Burlington Magazine*, 112, no.810.
Orton, F. and Pollock, G.,'Les Données Bretonnantes: la Prairie de la Représentation', *Art History*, vol. 3, no. 3.
Rewald, John, 'Theo Van Gogh, Goupil, and the Impressionists', *Gazette des Beaux-Arts*, 6th ser. 81, 1973.

Exhibition Catalogues

The Crisis of Impressionism, Ann Arbor,1979-80.
The New Painting: Impressionism 1874-1886, National Gallery of Art, Washington, 1986.
The Art of Paul Gauguin, National Gallery of Art, Washington, 1988.
The Prints of the Pont-Aven School: Gauguin and his Circle in Brittany, London, Royal Academy, 1989.

List of Illustrations

Colour Plates

1. Interior of the Artist's Home, rue Carcel
 1881. Oil on canvas, 130 x 162 cm. Oslo, National Gallery

2. Snow Scene
 1883. Oil on canvas. Private Collection

3. Gauguin at his Easel
 1885. Oil on canvas, 65 x 54.3 cm. Switzerland, Private Collection

4. Still Life with Mandoline
 1885. Oil on canvas, 64 x 53 cm. Paris, Musée d'Orsay

5. The Beach at Dieppe
 1885. Oil on canvas. Copenhagen, Ny Carlsberg Glyptotek

6. Still Life with Horse's Head
 1885. Oil on canvas. Paris, Private Collection

7. Study for 'Four Breton Women'
 1886. Coloured chalk, 48 x 32 cm. Glasgow, Burrell Collection

8. Four Breton Women
 1886. Oil on canvas, 72 x 91 cm. Munich Bayerischen Staatsgemäldesammlungen

9. Still Life with Portrait of Laval
 1886. Oil on canvas, 46 x 38 cm. Josefowitz Collection

10. Tropical Vegetation, Martinique
 1887. Oil on canvas, 116 x 89 cm. Edinburgh, National Gallery of Scotland

11. Two Girls Bathing
 1887. Oil on canvas, 92 x 72 cm. Buenos Aires, Museo Nacional de Bellas Artes

12. The Vision After the Sermon (Jacob Wrestling with the Angel)
 1888. Oil on canvas, 73 x 92 cm. Edinburgh, National Gallery of Scotland

13. Still Life with Three Puppies
 1888. 88 x 62.5 cm. New York, Museum of Modern Art

14. Van Gogh Painting Sunflowers
 1888. Oil on canvas, 73 x 92 cm. Amsterdam, Van Gogh Foundation

15. Night Café at Arles (Mme Ginoux)
 1888. Oil on canvas, 73 x 92 cm. Moscow, Pushkin State Musuem of Fine Arts

16. Old Women at Arles
 1888. Oil on canvas, 73 x 92 cm. Chicago, Art Institute

17. Grape Harvest at Arles (Human Anguish)
 1888. Oil on canvas, 73 x 92 cm. Copenhagen, Ordrupgaard Collection

18. Breton Girls by the Sea
 1889. Oil on canvas, 92 x 73 cm. Tokyo, National Museum of Western Art

19. Bonjour Monsieur Gauguin
 1889. Oil on canvas, 113 x 92 cm. Prague, National Gallery

20. Yellow Christ
 1889. Oil on canvas, 92.5 x 73 cm. Buffalo, Albright-Knox Art Gallery

21. Green Christ (Breton Calvary)
 1889. Oil on canvas, 92 x 73 cm. Brussels, Musées Royaux des Beaux-Arts de Belgique

22. Christ in the Garden of Olives
 1889. Oil on canvas, 73 x 92 cm. West Palm Beach, Norton Gallery of Art

23. Caribbean Woman with Sunflowers
 1889. Oil on canvas, 64 x 54 cm. New York, Private Collection

24. Self Portrait with Halo
 1889. Oil on canvas, 79.2 x 51.3 cm. Washington DC, National Gallery of Art (Chester Dale Collection)

25. The Seaweed Harvesters
 1889. Oil on canvas, 87.5 x 123 cm. Essen,
 Folkwang Museum

26. The Ham
 c.1889. Oil on canvas, 50 x 58 cm. Washington DC,
 The Phillips Collection

27. The Loss of Virginity (The Awakening
 of Spring)
 1891. Oil on canvas, 90 x 150 cm. Norfolk,
 Viriginia, the Chrysler Museum

28. Vahine note Tiare (Woman with a
 Flower)
 1891. Oil on canvas, 70 x 46 cm. Copenhagen, Ny
 Carlsberg Glyptothek

29. Faaturuma (Reverie)
 1891. Oil on canvas, 92 x 73 cm. Kansas City, the
 Nelson-Atkins Museum of Art

30. The Meal (The Bananas)
 1891. Oil on canvas, 73 x 92 cm. Paris, Musée
 d'Orsay

31. Ia Orana Maria (Hail Mary)
 1891. Oil on canvas, 114 x 89 cm. New York,
 Metropolitan Museum of Art

32. Nafea Faa Ipoipo (When Will you
 Marry?)
 1892. Oil on canvas, 101.5 x 77.5 cm. Basel,
 Kunstmuseum

33. Manao Tupapau (The Spirit of the
 Dead Keeps Watch)
 1892. Oil on canvas, 73 x 92 cm. Buffalo, Albright-
 Knox Art Gallery

34. Ta Matete (The Market)
 1892. Oil on canvas, 73 x 92 cm. Basel,
 Kunstmuseum

35. Fatata te miti (Near the Sea)
 1892. Oil on canvas, 68 x 91.5 cm. Washington DC,
 National Gallery of Art (Chester Dale Collection)

36. Tahitian Pastorals
 1892. Oil on canvas, 86 x 113 cm. Leningrad, State
 Hermitage Museum

37. Ea haere ia oe? (Where Are You Going?)
 1893. Oil on canvas, 91 x 71 cm. Leningrad, State
 Hermitage Museum

38. Hina tefatou (The Moon and the Earth)
 1893. Oil on canvas, 112 x 61 cm. New York,
 Museum of Modern Art

39. Self Portrait with a Palette
 c.1894. Oil on canvas, 92 x 73 cm. Private
 Collection

40. Aita tamari vahine Judith te parari
 (Annah the Javanese)
 1893-4. Oil on canvas, 116 x 81 cm. Private
 Collection

41. Mahana no atua (The Day of the God)
 1894. Oil on canvas, 66 x 108 cm. Chicago, Art
 Institute (Helen Birch Bartlett Collection)

42. Village under Snow
 1894. Oil on canvas, 65 x 90 cm. Paris, Musée
 d'Orsay

43. Nevermore
 1897. Oil on canvas, 60.3 x 116.2 cm. London,
 Courtauld Institute Galleries

44. Where Do We Come From? What Are
 We? Where Are We Going?
 1897. Oil on canvas, 141 x 376 cm. Boston,
 Museum of Fine Arts (Arthur Gordon Tompkins
 Residuary Fund)

45. The White Horse
 1898. Oil on canvas, 141 x 91 cm. Paris, Musée
 d'Orsay

46. Woman and Two Children
 1901. Oil on canvas, 97 x 74cm. Chicago, Art
 Institute (Helen Birch Boutlett Collection)

47. Woman with a Fan
 1902. Oil on canvas, 92 x 73 cm. Essen, Folkwang
 Museum

48. Contes Barbares (Primitive Tales)
 1902. Oil on canvas, 130 x 89 cm. Essen, Folkwang
 Museum

Text Figures

1. Photograph of Paul Gauguin in 1873

2. The Artist's Wife, Mette
 1877. Marble. Courtauld Institute, London

3. Nude Sewing
 1880. Oil on canvas, 115 x 80 cm. Copenhagen, Ny Carlsberg, Glyptotek

4. Landscape After Cézanne
 1885. Copenhagen, Ny Carlsberg, Glyptotek

5. Les misérables: Self-Portrait with a Portrait of Bernard
 1888. Oil on canvas, 45 x 55 cm. Amsterdam, Stedelijk Museum

6. Vincent Van Gogh
 The Starry Night
 1889. Oil on canvas, 73.7 x 91.4 cm. New York, Museum of Modern Art

7. Still Life with Japanese Print
 1889. Oil on canvas, 73 x 92 cm. New York, Ittleson Collection

8. Cup in the Form of a Self-Portrait
 Glazed stoneware

9. 'Soyez amoureuses vous serez heureuses'
 1889. Painted wood, 97 x 75 cm. Boston, Museum of Fine Arts

10. 'Soyez symboliste' (caricature portrait with Jean Moréas). Reproduced in 'La Plume'.
 c. 1891. 34 x 40 cm. Paris, Bibliothèque Nationale

Comparative Figures

11. Georges Seurat
 Young Woman Powdering Herself
 c.1889-90. Oil on canvas, 94.2 x 79.5 cm. London, Courtauld Institute Galleries

12. Breton Women at a Fence Gate, from 'Bretonneries'
 1889. Zincograph on paper, 17 x 21.5 cm. Paris, Bibliothèque Nationale

13. Paul Cézanne
 Still Life with Compotier
 c.1880. Oil on canvas. Paris, Private Collection

14. Paul Cézanne
 Landscape With a Viaduct: Mont Sainte-Victoire
 c.1885-7. Oil on canvas, 65 x 81 cm. New York, Metropolitan Museum of Art

15. Bather in Brittany
 c.1887. Black chalk and pastel, 58.4 x 34.9 cm. Chicago, Art Institute

16. Vincent Van Gogh
 Van Gogh's Bedroom at Arles
 1889. Oil on canvas. Paris, Musée d'Orsay

17. Vase with Breton scenes
 1887. Brussels, Musées Royaux d'Art et d'Histoire

18. Gustave Courbet
 Bonjour Monsieur Courbet
 1854. Oil on canvas, 129 x 149 cm. Montpellier, Musée Fabre

19. Self-Portrait with Yellow Christ
 1889. Oil on canvas, 38 x 46 cm.

20. Letter from Gauguin to Van Gogh, with sketch of 'Christ in the Garden of Olives'

21. Jean-François Millet
 The Gleaners
 1857. Oil on canvas, 83.5 x 111 cm. Paris, Musée d'Orsay

22. Jean Baptiste Chardin
 The Tea Pot
 1764. Oil on canvas, 32.5 x 40 cm. Boston, Museum of Fine Arts

23. Edouard Manet
 Olympia
 1863. Oil on canvas, 130.5 x 190 cm. Paris, Musée d'Orsay

24. Portrait of a Woman with Still Life by Cézanne
 1890. Oil on canvas, 61.6 x 51.4 cm. Chicago, Art Institute

25. Page from 'Ancien Culte Mahorie'
 Paris, Cabinet des Dessins

26. Gustave Caillebotte
 Place de l'Europe on a Rainy Day
 1877. Oil on canvas, 212.1 x 276.4 cm. Chicago, Art Institute

27. Sketch for 'Where Do We Come From? What Are We? Where Are We Going?'
 1897. Paris, Cabinet des Dessins

28. Edgar Degas
 Horses on the Course at Longchamp
 c.1873-5. Oil on canvas, 30 x 40 cm. Boston, Museum of Fine Arts

29. Nirvana (Portrait of Jacob Meyer de Haan)
 1889. Oil on linen, 20 x 29 cm. Hartford, Ct., Wadsworth Atheneum

Interior of the Artist's Home, rue Carcel

1881. Oil on canvas, 130 x 162 cm. Oslo, National Gallery

In 1881, at the time of painting this work, Gauguin still had a successful career in stockbroking. The affluent lifestyle that this gave the family, including his wife Mette (probably the woman seated at the upright piano) and their four children is made clear in this painting. The solid bourgeois respectability is reflected in the cosy interior and the domestic comforts made evident in the foreground by the prominent still life and the small work basket on the table.

This painting was included in the seventh Impressionist exhibition of 1882, where Gauguin exhibited 13 works, and which he helped to organize. In treatment, however, the painting is quite different from typical Impressionist works of this period. It is produced on a much larger scale than Gauguin normally used at this time, quite different from the smaller, more intimate works of his Impressionist friends who favoured portable canvases for working in the open air. The rather dark tonality was something that was remarked upon by several critics, who found it heavy in comparison with typical Impressionist paintings. It was perhaps because of its rather orthodox treatment and the image of family life that it proclaims that made Mette Gauguin keep the painting in her personal collection until 1917.

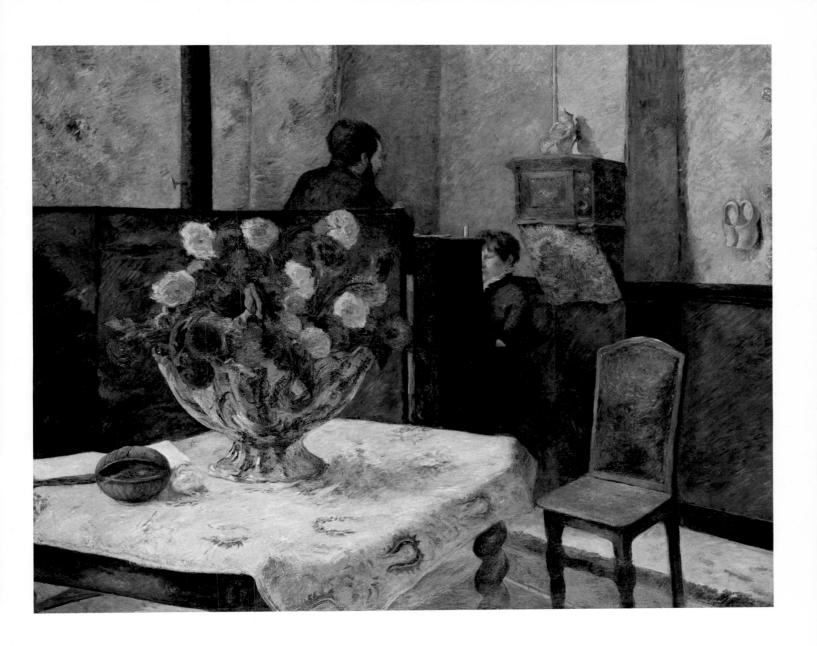

Snow Scene

1883. Oil on canvas. Private Collection

By 1883, and as a direct result of the collapse of the stock market the previous year, Gauguin's finances were in disarray, and he began to consider a change in career. This painting demonstrates an attempt to align himself with the landscape Impressionist painters, perhaps from a desire to make money from the sale of his works, and is in marked contrast to the more laboured works like Plate 1, produced while he could still consider himself an amateur.

The subject of a snowy landscape was a typical Impressionist device to enable the artist to study the effects of colour reflections on a white surface and was particularly favoured by Sisley. However, the handling in the sky and the foliage is more reminiscent of the work of Monet from this period. The spontaneity of the brushwork and the subject matter would suggest that the canvas was painted out of doors, but there is a small related sketch without the two foreground figures, probably done in front of the motif, which presumably forms the basis for this more finished, studio painting. This means that the two women were added later, and demonstrates that even at this date Gauguin did not feel tied to working solely from nature, and had already begun to use the subject of two conversing women which was to recur in his mature work, such as *Nafea Faa Ipoipo* (Plate 32).

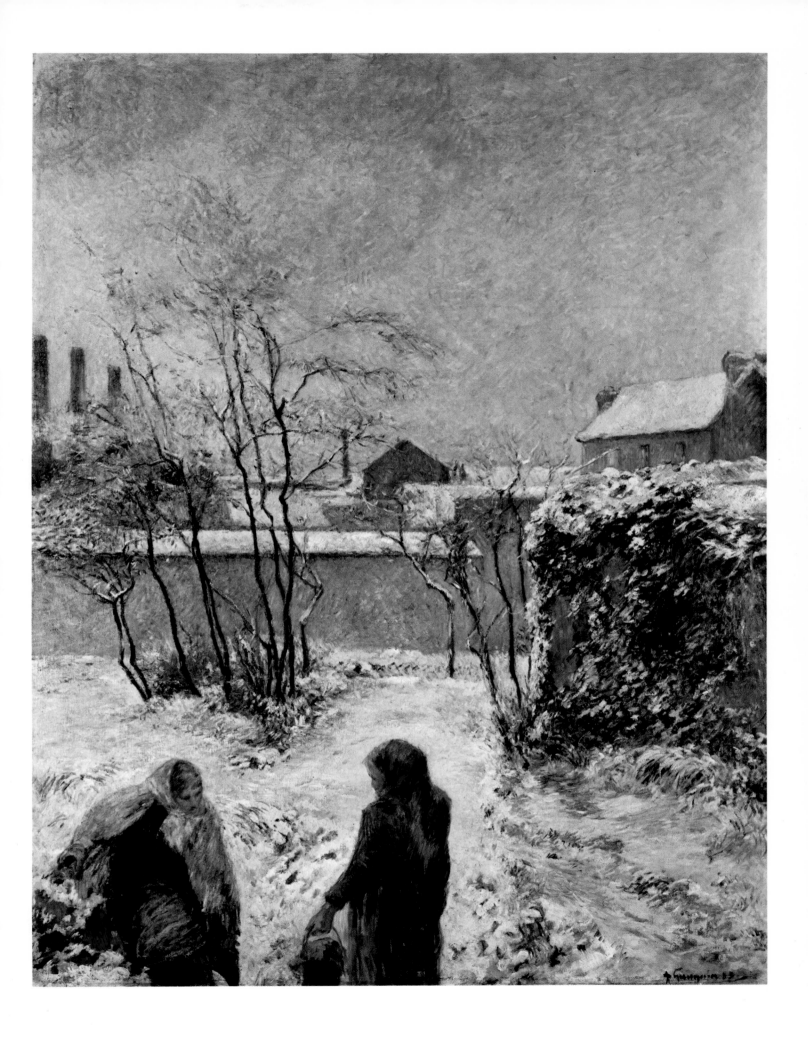

3 Gauguin at his Easel

1885. Oil on canvas, 65 x 54.3 cm. Switzerland, Private Collection

From November 1884 to June 1885 Gauguin lived in Copenhagen with his wife and family, and it was there that he painted this self-portrait. His letters to friends in Paris chronicle what was for him a difficult period - he missed the cultural life of Paris, disliked the Danes, his wife's family in particular, and the harsh climate meant that he could do little work in the open air. Increasingly he was forced to work indoors, without a model, and his subject matter betrays these constraints. His work became increasingly premeditated and he wrote to Schuffenecker, 'above all, don't perspire over a picture. A strong emotion can be translated immediately: dream on it and seek its simplest form.' However, in the execution, particularly in the flickering brushwork, this painting is still close to the work of his Impressionist years.

Gauguin's rather romantic characterization of the solitary figure labouring in a garret establishes the tenor of much later self-portraits, in which he depicted himself as artistic martyr, culminating in the series of works of 1889 (Plates 20, 21, 22, 24) in which he increasingly identified with Christ.

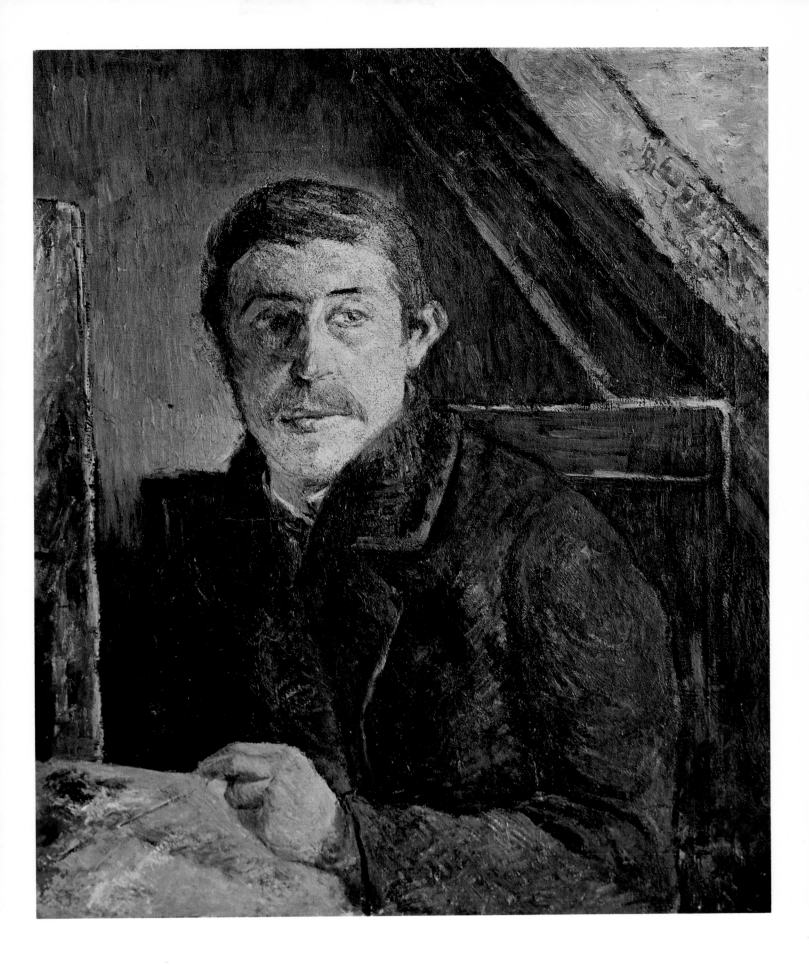

4 Still Life with Mandoline

1885. Oil on canvas, 64 x 53 cm. Paris, Musée d'Orsay

The significance of this still life seems to have been highly personal and it was probably painted either while Gauguin was still in Copenhagen with his wife's family or just after he arrived back in Paris with Clovis. The canvas in the background can be identified as one from his collection by the artist Armand Guillaumin (1841-1927), with whom Gauguin had painted in the summer of 1881. The mandoline was one of the possessions that he took on all his travels and the vase is very similar to those that Gauguin started to make the following year with Chaplet.

At the same time, the work is an exercise in formal arrangement, with the arabesques of the objects on the table being offset by the horizontals and verticals in the background. Similarly, he has chosen his colours with great care, contrasting the oranges in the peonies and in the landscape with the complementary blues of the wall and vase.

5 The Beach at Dieppe

1885. Oil on canvas. Copenhagen, Ny Carlsberg Glyptotek

In July 1885 Gauguin went to Dieppe, where he stayed at the house of a friend until October of that year, except for a few weeks spent in London. The subject matter of sea bathing was to interest him increasingly at this time, and he showed another version of the same theme at the eighth Impressionist exhibition, in which the women in the waves assume greater prominence within the picture space (the work is now in the National Museum of Western Art, Tokyo). Gradually, the theme became more symbolic and the waves serve as a metaphor for sexual fulfillment. At this stage, however, the subject retains a naturalistic flavour and treatment, with a rapid impressionistic brushstroke and an attempt at representing an everyday scene. At the same time, there is a marked gulf between the four figures huddled on the shore and the sea bathers; each group seems self-contained, isolated and unaware of the other's existence, a notion that Gauguin would explore again in works like the *Yellow Christ* (Plate 20).

Still Life with Horse's Head

1885. Oil on canvas. Paris, Private Collection

Fig. 11
Georges Seurat
Young Woman Powdering Herself
c.1889-90. Oil on canvas, 94.2 x 79.5 cm.
London, Courtauld Institute Galleries

In the late summer of 1885 Gauguin travelled to London on business and this painting may have been produced during that trip. The work is quite unique in his oeuvre, and seems to represent a self-conscious attempt at fusing the ingredients of different cultures, worked in an avant-garde style. The horse's head is borrowed from the Elgin Marbles, on display in the British Museum, and coupled with Japanese fans and a puppet of the type that were popular in Paris at the time. Such plunderings from non-Western sources was later to become commonplace in Gauguin's work, when he used them deliberately to attempt to create a 'primitive' flavour. However, it is the handling of the work that makes it unique, for the loose brushwork of earlier Impressionist style paintings, like *Snow Scene* (Plate 2) has been systematized into the pointillist technique used by Seurat and Signac at this time (Fig. 11). Gauguin has rejected the methods of the Impressionists and attempted to paint in the manner of the most advanced Parisian artists.

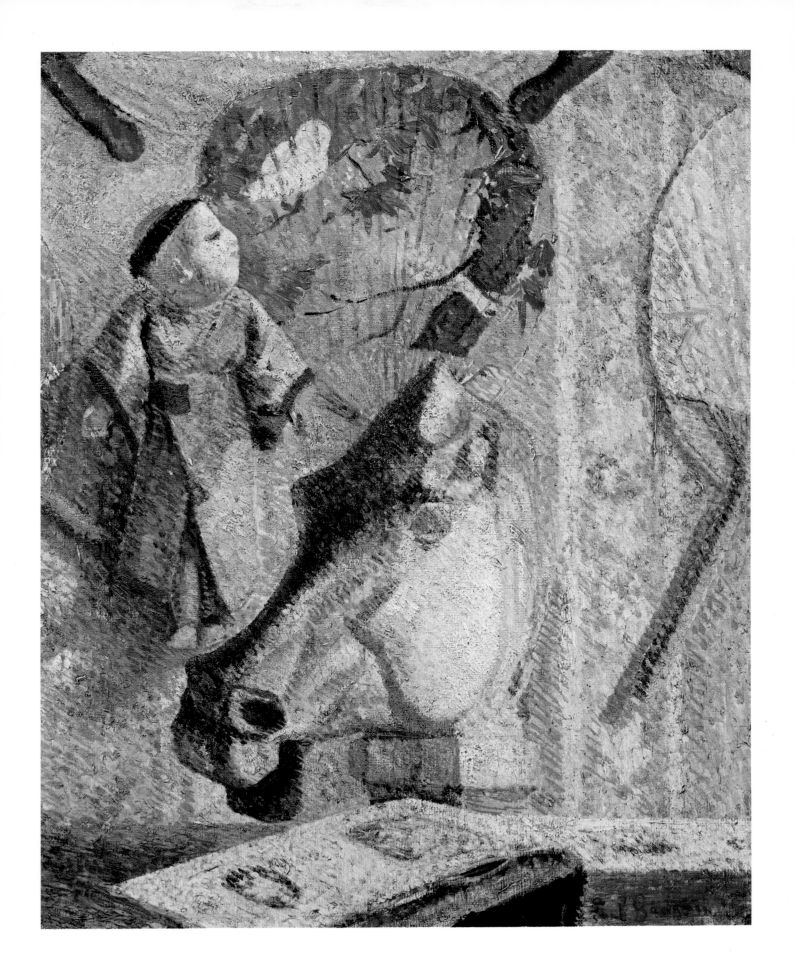

7 Study for 'Four Breton Women'

1886. Coloured chalk, 48 x 32 cm. Glasgow, Burrell Collection

Gauguin left Paris in the summer of 1886 to work in Brittany, where he hoped both that it would be cheaper to live and to find picturesque subject matter. At first, he revelled in the countryside and wrote to Schuffenecker: 'I love Brittany, I find something savage, primitive here. When my clogs echo on this granite earth, I hear the dull, muffled powerful note that I seek in my painting.'

This pastel has presumably been done from the model and was to serve as the basis for a vase and a painting, the *Four Breton Women* (Plate 8), which Gauguin produced back in Paris that winter. The traditional costume of the bodice and coiffe had largely been abandoned for everyday wear by the 1880s and we must assume that the model is merely supplementing her income by wearing them for the artist.

Four Breton Women

1886. Oil on canvas, 72 x 91 cm. Munich Bayerischen Staatsgemäldesammlungen

Although this work represents Breton subject matter, it was probably painted from memory and from sketches back in Paris in the winter of 1886-7 (see Plate 7), an indication that Gauguin was already edging towards the synthetist treatment for his subjects by this time. The forms have been deliberately flattened, with attention paid to the white headresses and small shawls worn by the women, and a deliberate suppression of atmosphere and distance within the picture space by avoidance of a horizon and by the use of saturated colours. The figure of the woman to the righthand side who is adjusting her clog is a free adaptation of the woman in the garden in *Snow Scene* (Plate 2).

Despite its authentic 'primitive' feel, the work is an elaborate fiction. The fancy dress that the woman are wearing had been abandoned by the Breton peasantry except for the celebration of pardons, and they were enjoying a period of relative prosperity, in part financed by a flourishing tourist trade. By painting works like this from memory, Gauguin could confect a vision of Breton life that was much closer to his notion of what constituted a 'primitive' existence than any that he could have found at this time (Fig. 12).

Fig. 12
Breton Women at a Fence Gate, from 'Bretonneries'
1889. Zincograph on paper, 17 x 21.5 cm.
Paris, Bibliothèque Nationale

Still Life with Portrait of Laval

1886. Oil on canvas, 46 x 38 cm. Josefowitz Collection

Fig. 13
Paul Cézanne
Still Life with Compotier
c. 1880. Oil on canvas. Paris, Private Collection

Gauguin met Charles Laval (1862-94) at Pont-Aven in the summer of 1886 and the younger artist became his pupil. The two were to journey to Panama and Martinique together the following year. Gauguin's role as mentor is alluded to in the way in which Laval gazes fixedly at the ceramic pot which was made by Gauguin in the winter of 1886-7, when he worked in Paris with the ceramicist Chaplet.

The still life with its piled up fruits, treated with tight diagonal brushstrokes and laid out on a white cloth, is reminiscent of Cézanne's painting *Still Life with Compotier* which Gauguin owned at this date (Fig. 13). At the same time, the oddly truncated head in the foreground is a homage to Degas, who had exhibited with Gauguin at the final Impressionist exhibition that year.

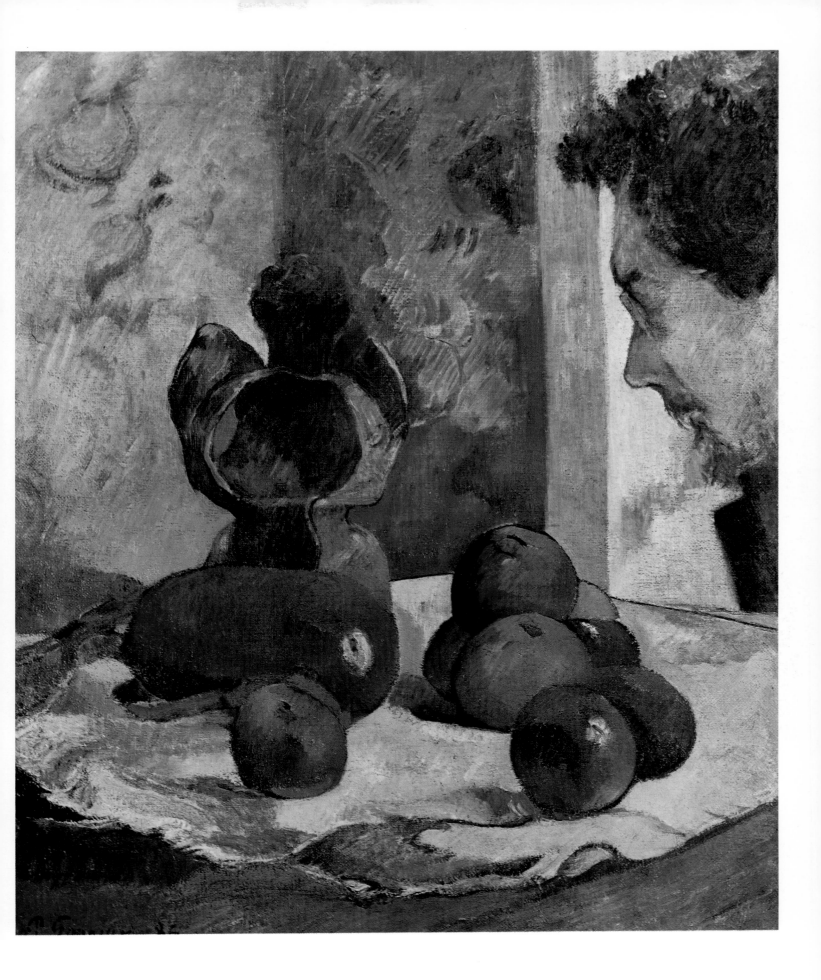

1887. Oil on canvas, 116 x 89 cm. Edinburgh, National Gallery of Scotland

Fig. 14
Paul Cézanne
Landscape with a Viaduct: Mont Sainte-Victoire
c.1885-7. Oil on canvas, 65 x 81 cm. New York, Metropolitan Museum of Art

Gauguin and Charles Laval journeyed to Panama in April 1887 and stayed there for a few weeks before going to Martinique, where this landscape was produced. The view is of the bay of Saint-Pierre, with the volcanic Mount Pelée in the background. He had painted very few pure landscapes since his Impressionist days and this is an unusual work in Gauguin's oeuvre. This suggests that he was conjuring up a vision of a tropical paradise unsullied by any human contact, and in search of which he was later to travel to Tahiti. The regular patterning of the brush-strokes which unify the picture surface and which contribute to a flattening effect, coupled with the absence of any aerial perspective and the saturated jewel-like colours, owe a great deal to the work of Cézanne, which continued to influence Gauguin at this time (Fig. 14).

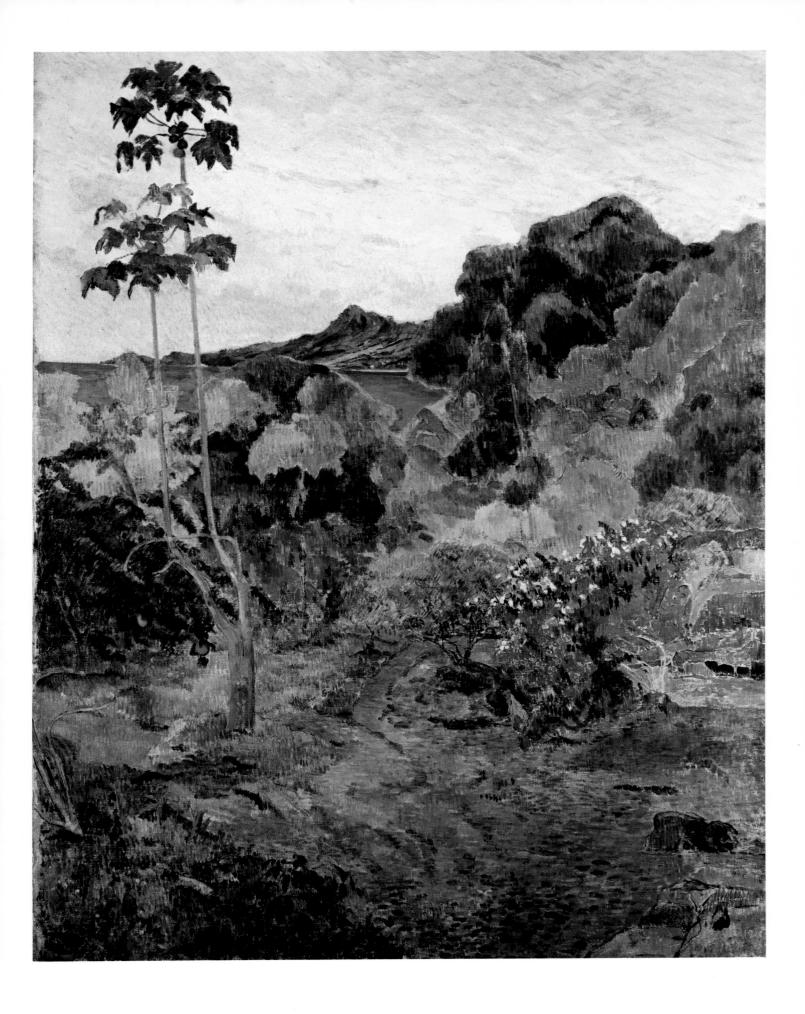

Two Girls Bathing

1887. Oil on canvas, 92 x 72 cm. Buenos Aires, Museo Nacional de Bellas Artes

Fig. 15
Bather in Brittany
c. 1887. Black chalk and pastel, 58.4 x 34.9cm.
Chicago, Art Institute

Gauguin had already turned to the theme of bathing in works like *The Beach at Dieppe* (Plate 5), but this was his first attempt at the subject of two female bathers which he was to develop in Tahiti. When the work went on display at the Parisian gallery of Boussod and Valadon in February 1888, the anarchist critic Félix Fénéon remarked that: '...one of the women in the picture, severed at the waist by the water, is broad shouldered and opulently bourgeois in build. On the adjoining grass, amazed, stands a little servant girl with stiff, cropped hair; she stares, dumbfounded, at her shivering companion, her left hand on her knee, unable to decide whether or not to take the final step' (Fig. 15).

Fénéon has analyzed the work in terms of an implicit class conflict because the strangely androgynous central nude figure precludes any conventional reading of a study in voluptuous nudity. In fact, the two anonymous figures are much closer to a series of nude male boy wrestlers that Gauguin painted the following year. In these works he seems to be attempting to achieve a broadly integrated surface pattern and to reconcile that with an impressionistic brushstroke.

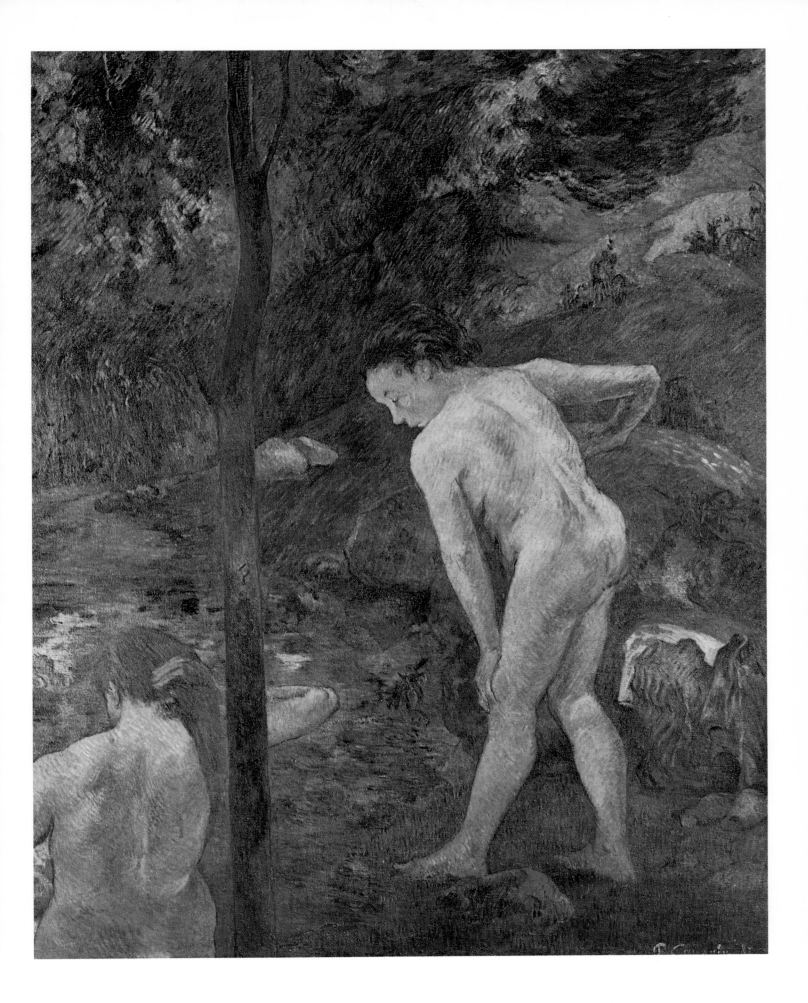

12 The Vision After the Sermon (Jacob Wrestling with the Angel)

1888. Oil on canvas, 73 x 92 cm. Edinburgh, National Gallery of Scotland

Since 1891 this painting has been regarded as the watershed in Gauguin's work, when he finally rid himself of the vestiges of an Impressionist style and formulated his own synthetist idiom. However, Gauguin had been evolving in that direction before this, in works such as *Four Breton Women* (Plate 8). The reason for this painting being given such prominence is that it was the one chosen by the symbolist writer Albert Aurier to elucidate his theories in the article 'Symbolism in painting: Gauguin', published that year. In it he described the work: 'Far, far away, on a fabulous hill, where the earth appears a gleaming red, the biblical fight between Jacob and the Angel takes place...While these two legendary giants, whom distance transforms into pygmies, fight their terrible fight, some women watch, interested and naive, doubtless not understanding much of what is happening on that fabulous crimson-flushed hill...the artist always has the right to exaggerate those directly significant qualities (forms, lines, colours, etc.) or to attentuate them... not only according to his individual vision, [but also]...according to the needs of the Idea to be expressed.'

Later commentators have chosen to follow Aurier's lead and regard the non-naturalistic features of the work as being revolutionary rather than as part of a continuing process in Gauguin's stylistic development.

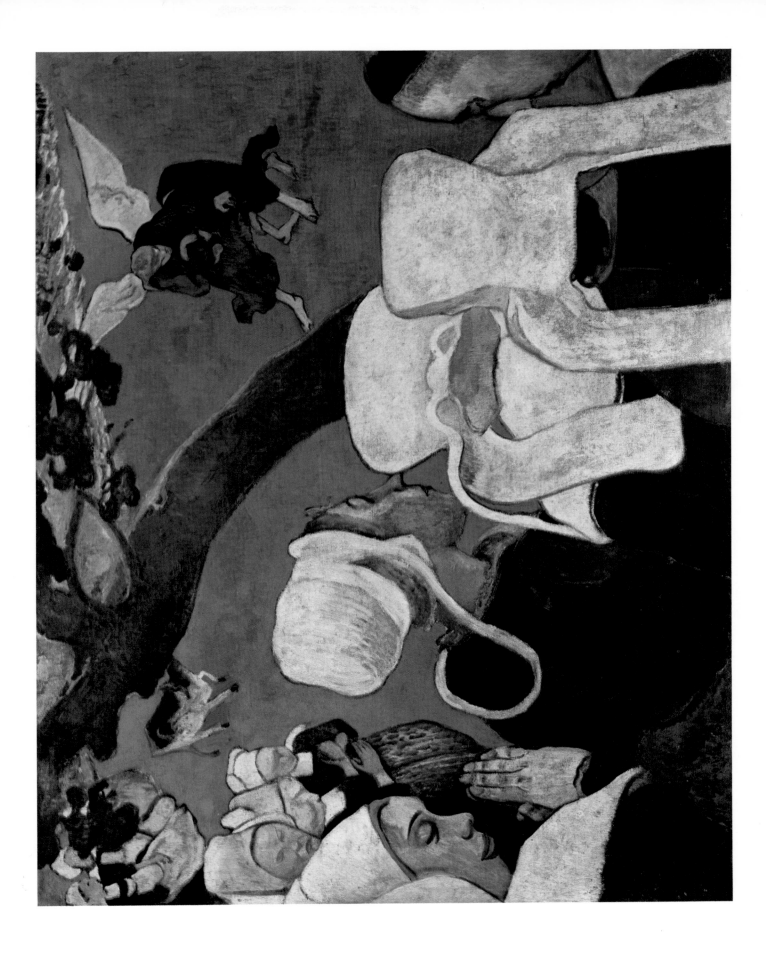

13 Still Life with Three Puppies

1888. 88 x 62.5 cm. New York, Museum of Modern Art

Gauguin wrote to Schuffenecker from Pont Aven on 14 August 1888, about the same time that he painted this still life, 'a hint - don't paint too much directly from nature. Art is an abstraction. Study nature then brood on it and treasure the creation which will result, which is the only way to ascend towards God - to create like our Divine Master.'

The attempt at a contrived `primitive' quality which Gauguin developed in Brittany, is particularly marked in this painting. The *cloisonné* effect of *The Vision* (Plate 12) is developed, so that objects are outlined and strangely isolated against the backdrop of the tablecloth. The influence of Japanese art is particularly evident, and the composition may have been based on a print by Kuniyoshi. Added to the high viewpoint, and with the suppression of any tonal modelling, the two-dimensional surface of the picture space is exploited. In addition, the self-conscious naivety of the subject is enhanced by the grouping of objects into threes.

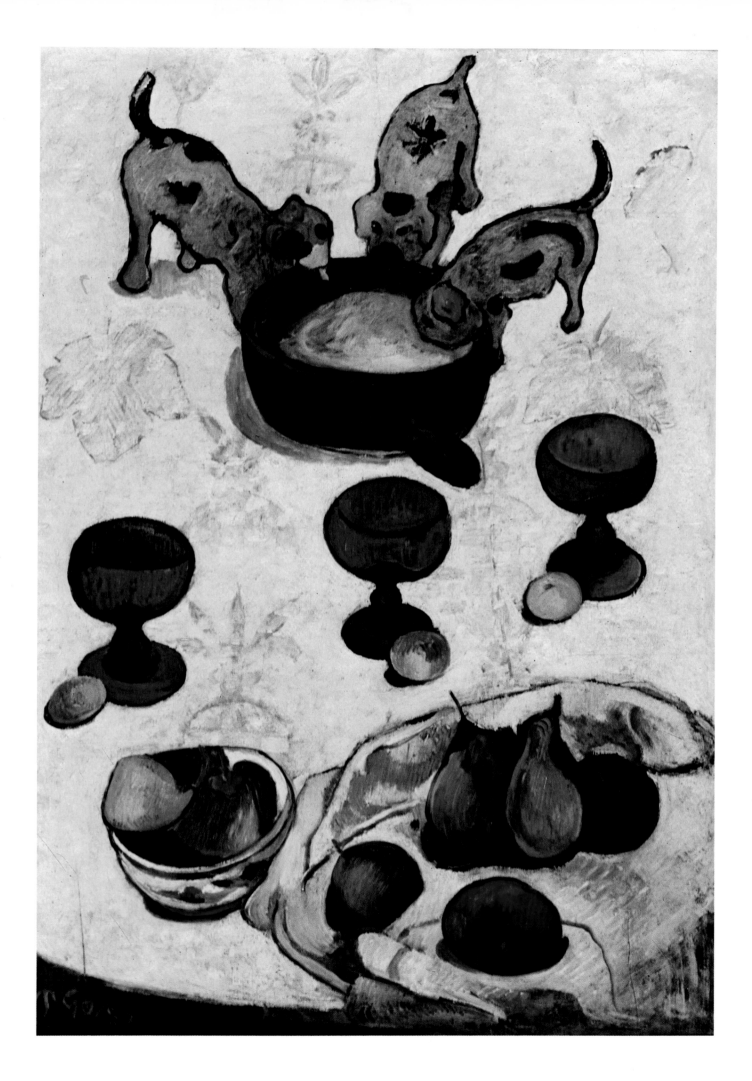

Van Gogh Painting Sunflowers

1888. Oil on canvas, 73 x 92 cm. Amsterdam, Van Gogh Foundation

Fig. 16
Vincent Van Gogh
Van Gogh's Bedroom at Arles
1889. Oil on canvas. Paris, Musée d'Orsay

On 23 October 1888 Gauguin arrived in Arles to live and work with Vincent Van Gogh, in part financed by Theo Van Gogh who offered him a monthly income in return for his canvases and for acting as a companion to his brother. The artists worked together for two months, often on the same motif, which they continued to treat in markedly different ways (Fig. 16). Gauguin had written to Schuffenecker in August advising him against painting from nature, whereas Van Gogh was resistant to adopting this method in his working procedure as this work testifies, preferring to record his impressions in front of the motif. Gauguin has once again adopted the high viewpoint he had used in *Still Life with Three Puppies*, which allows him to flatten the subject and treat it with the *cloisonné* style he had formulated in Brittany with Bernard. The subject, in particular the background, is treated as a configuration of flat colours, each compartmentalized and simplified, as in the enamel work from which the style derived its name.

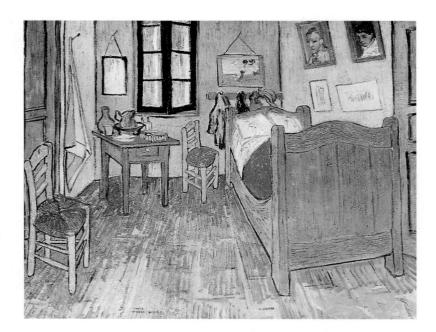

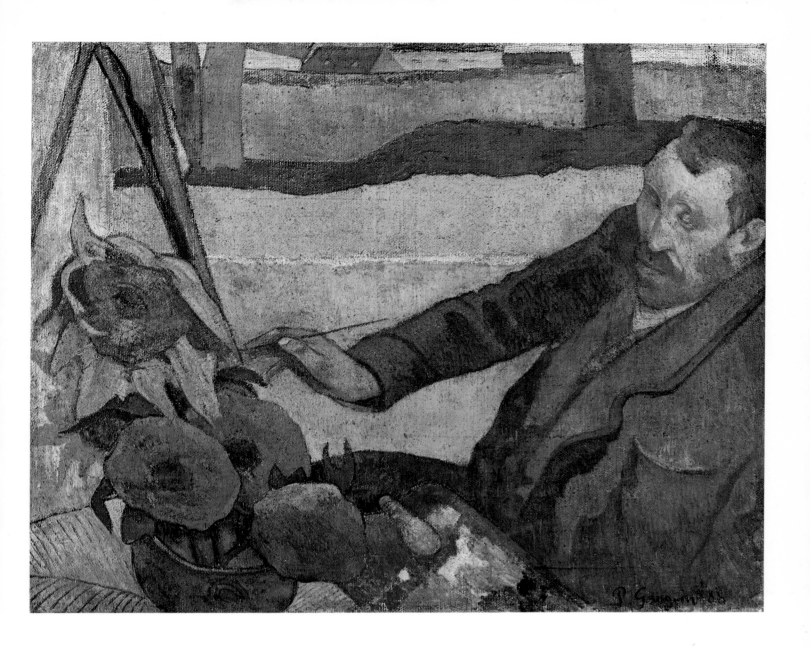

15 Night Café at Arles (Mme Ginoux)

1888. Oil on canvas, 73 x 92 cm. Moscow, Pushkin State Musuem of Fine Arts

Early in November 1888 Vincent Van Gogh wrote to his brother that Gauguin was attempting a picture of the night café that he had already painted. Madame Ginoux was the proprietor of the Café de la Gare in Arles, where Van Gogh had lodged upon his arrival in the Midi and the establishment was frequented by prostitutes, three of whom Gauguin has depicted in the background of his version. Gauguin himself described it to Bernard: 'I've done the café which Vincent likes very much and I like rather less. Basically, it isn't my thing, and the coarse local colour doesn't suit me...At the top, red wallpaper and three prostitutes. One with hair bristling with hair curlers, the second seen from behind in a green shawl. At the lefthand side, a man asleep. A billiard table. In the foreground, a fairly well-finished figure of an Arlesienne... The picture is crossed by a band of blue smoke, but the figure in front is much too proper...'

It is clear from the sketch that accompanied this description, and also from the fact that the work is signed in two places (on the marble table and on the edge of the billiard table) that Gauguin later reworked the canvas, adding the figure to the extreme lefthand side and the man conversing with the prostitutes. These two figures, and Madame Ginoux herself, had already been portrayed by Van Gogh in other works.

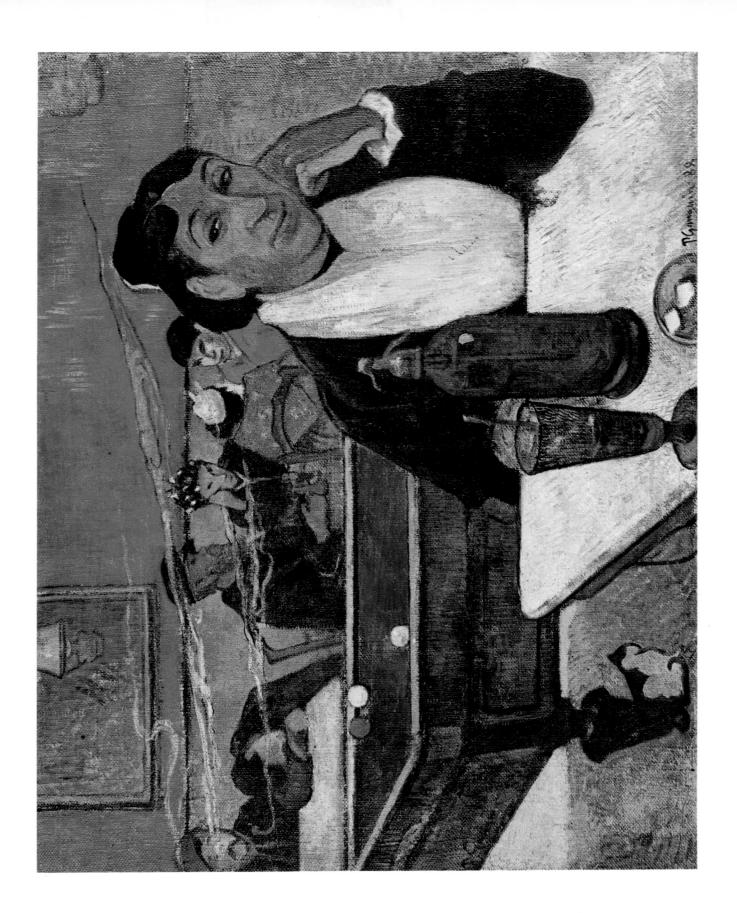

Old Women at Arles

1888. Oil on canvas, 73 x 92 cm. Chicago, Art Institute

In the autumn of 1888, Van Gogh began a series of paintings depicting the public gardens in Arles, and this is a further instance of Gauguin's choice of the same subject matter, painted in mid-November. However, the treatment is quite different: whereas Van Gogh continued to paint from the motif, Gauguin's version is highly stylized, based on the play of geometricized shapes, treated with bold washes of colour. The absence of any horizon or aerial perspective contributes to a flat picture surface, which owes something to the influence of Japanese art. The objects in the background (the pond, fountain and park bench) are seen as if from above whereas the elements in the foreground and middle distance (including the young trees packed in straw as protection against the frost) are viewed as if at eye-level. The woman in the foreground is Madame Ginoux, whom both Van Gogh and Gauguin (in the *Night Café at Arles*, Plate 15) had already depicted. This is one of the works that Theo Van Gogh acquired from Gauguin in the winter of 1888-9.

Grape Harvest at Arles (Human Anguish)

1888. Oil on canvas, 73 x 92 cm. Copenhagen, Ordrupgaard Collection

At the beginning of November 1888 Van Gogh described this work in a letter to Theo, 'just now [Gauguin] has in hand some women in a vineyard, altogether from memory, but if he does not spoil it or leave it unfinished it will be very fine and very unusual.' That the scene is painted from the imagination and not from life is evident from the fact that the scene is peopled with Breton peasant women whom Gauguin could not have seen for several months (Fig. 17).

Originally, the work was entitled *Grape Harvest at Arles*, but Gauguin later renamed it *Human Anguish*, lest its symbolic connotations be overlooked. The pose of the crouching female figure in the foreground was a direct quotation from a Peruvian mummy that Gauguin had seen in the ethnographic museum in Paris, and which was to recur in later works, most notably in *Where Do We Come From?* (Plate 44). Her pose evokes grief and guilt, perhaps sexual guilt, ironically referred to in the abundance of the harvest which surrounds her. Indeed, the backdrop of the harvest is treated like water, with the suggestion of frothy waves in the foreground, which for Gauguin represented female sexual abandonment. The picture may be meant to evoke a post-seduction scene, a theme which Gauguin explored to its fullest in *The Loss of Virginity* (Plate 27).

Fig. 17
Vase with Breton scenes
1887. Brussels, Musées Royaux d'Art et d'Histoire

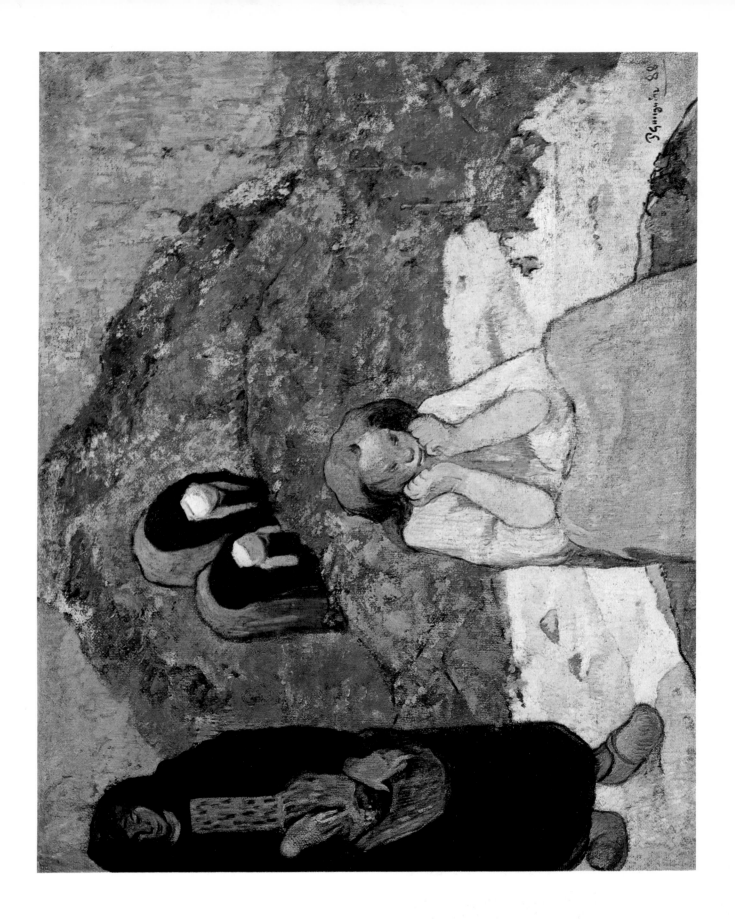

18 Breton Girls by the Sea

1889. Oil on canvas, 92 x 73 cm. Tokyo, National Museum of Western Art

By the time he painted this work, Gauguin had exhausted the possibilities for 'savage' representations of Breton life at Pont-Aven, which was becoming increasingly commercialized. In July and August of 1889 and again in October he went to the more remote area of Le Pouldu, in an attempt to recapture the more exotic aspects of Breton life in his work. This canvas demonstrates the kind of ambivalence that he experienced at this time. The subject is as picturesque as *Four Breton Women* (Plate 8), and as such would have appealed to a Parisian audience who subscribed to the myth of the remote, archaic way of life in Brittany. At the same time, however, he has deliberately made the image more crude and less immediately appealing by grossly enlarging the children's coarse feet and giving them baleful expressions. He has also attempted to create a strong, forceful image, with the two interlinked bodies against a colourful, simplified background, a motif which he was to use again in Tahiti, as in *Nafea Faa Ipoipo* (Plate 32).

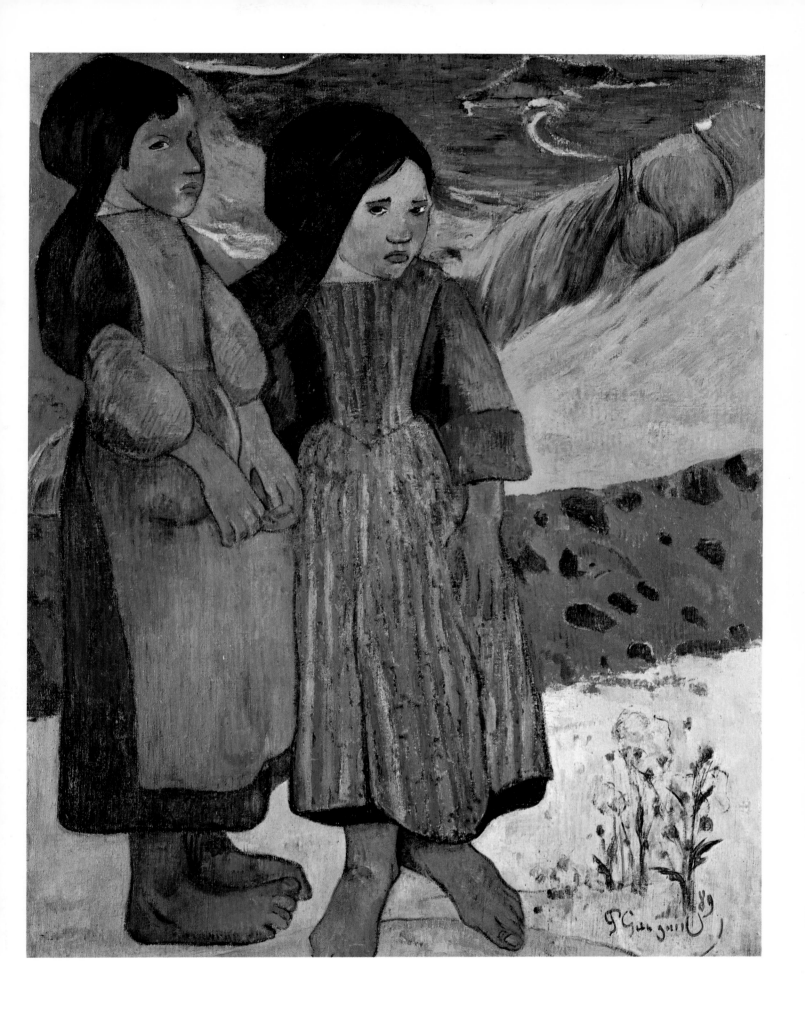

Bonjour Monsieur Gauguin

1889. Oil on canvas, 113 x 92 cm. Prague, National Gallery

Fig. 18
Gustave Courbet
Bonjour Monsieur Courbet
1854. Oil on canvas, 129 x 149 cm. Montpellier, Musée Fabre

This work was produced in response to the painting by Courbet that Gauguin and Van Gogh had seen together in the Musée Fabre in Montpellier in December 1888. *Bonjour Monsieur Courbet* (Fig. 18) formed part of the Bruyas collection, and Gauguin's version, painted several months later, bears little overt resemblance to the original. In Courbet's version, the artist depicted himself in the guise of a wandering Jew who meets his patron Bruyas, accompanied by his manservant on the road to Montpellier. Bruyas doffs his hat to the artist, and the servant stands with head respectfully lowered. In depicting himself thus, Courbet has referred to the changing status of the artist in the nineteenth century and has represented himself in a romantic role, as an essentially misunderstood, creative genius, working outside the norms of bourgeois society. It was to this aspect that Gauguin responded in this version, and the flavour of the original has been retained, although the composition and figures are markedly different. From his earliest self-portraits, such as *Gauguin at his Easel* (Plate 3), Gauguin had cast himself in the role of the artistic martyr and in 1889 this was to reach a climax in works like the *Green Christ* (Plate 21) and *Christ in the Garden of Olives* (Plate 22).

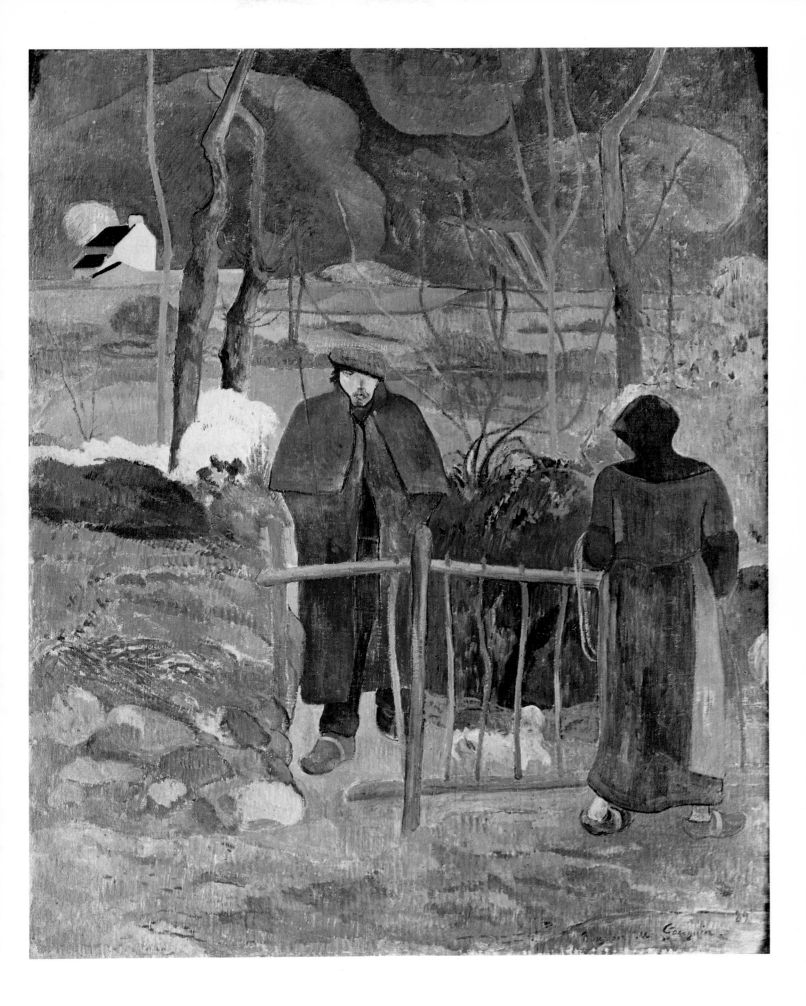

Yellow Christ

1889. Oil on canvas, 92.5 x 73 cm. Buffalo, Albright-Knox Art Gallery

In *Yellow Christ*, Gauguin returned to religious subject matter for the first time since painting *The Vision* (Plate 12) a year previously. In fact, the two works have a number of similarities. Both are essentially synthetic, distilling the essence of the subject in order to render it as forcibly as possible, and relying on the use of colour to symbolic ends. They share the same theme; of the naivety of the allegedly simple Breton peasants, who by their faith transform what was simply a statue of Christ into a living embodiment of his suffering. In fact, the original for the statue was borrowed from a seventeenth-century polychromed crucifix that Gauguin had copied in a church at Trémalo, near Pont-Aven. The use of this kind of folk art, part of his repertoire of 'primitive' imagery, was used in the slightly later *Green Christ* (Plate 21).

Octave Mirbeau described this painting in 1891: 'In a completely yellow landscape, a dying yellow, on top of a Breton hillside which the end of autumn turns a sad yellow, under a heavy sky, there is a wooden calvary, clumsy, rotting, disjointed, which stretches its warped arms into the air...a pitiful and barbaric Christ is daubed in yellow. At the foot of the Calvary, some peasants are kneeling...The sadness of this wooden Christ is inexpressible, his head is full of awful sadness...he seems to say to himself, seeing these miserable and ignorant creatures at his feet, "what if my martyrdom has been in vain?"'

Fig. 19
Self-Portrait with Yellow Christ
1889. Oil on canvas, 38 x 46 cm.

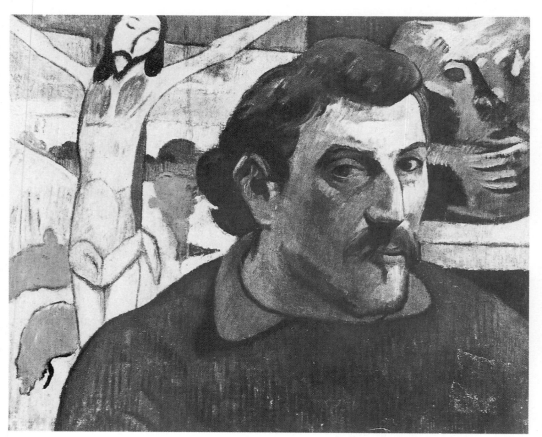

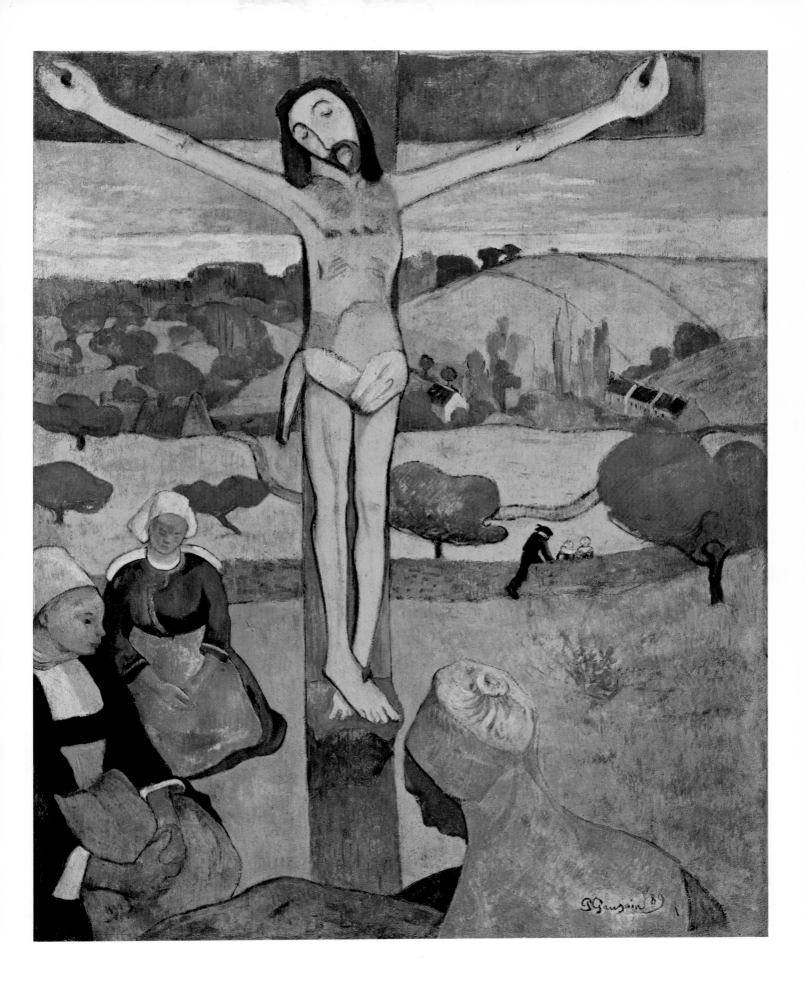

21 Green Christ (Breton Calvary)

1889. Oil on canvas, 92 x 73 cm. Brussels, Musées Royaux des Beaux-Arts de Belgique

Like the statue in the *Yellow Christ*, the *Green Christ* had an identifiable source in a mossy stone calvary that Gauguin had seen at Nizon near Pont-Aven. He has again treated the impact of religious faith on the Breton woman, who crouches in the foreground in front of the deposition, a graphic blending of the real and the illusory that had already been explored in both *The Vision* (Plate 12) and the *Yellow Christ* (Plate 20). Again, the counterpoise of the quotidien is suggested by expressive, apparently uninterested background figures, here a seaweed gatherer returning from the beach.

The picture may be seen as a later event in Christ's Passion - the bright colours of the *Yellow Christ* have given way to sombre tones, as his dead body is lifted down from the cross. Again, the face is a thinly-disguised self-portrait, another in the line of works in which Gauguin has dealt with the theme of martyrdom, likening his suffering to that of Christ. This notion of the artist as a special individual would have been re-inforced by his reading of Thomas Carlyle at this time, to whose work he explicitly referred in a contemporary portrait of the Belgian painter, Jacob Meyer de Haan (1852-95).

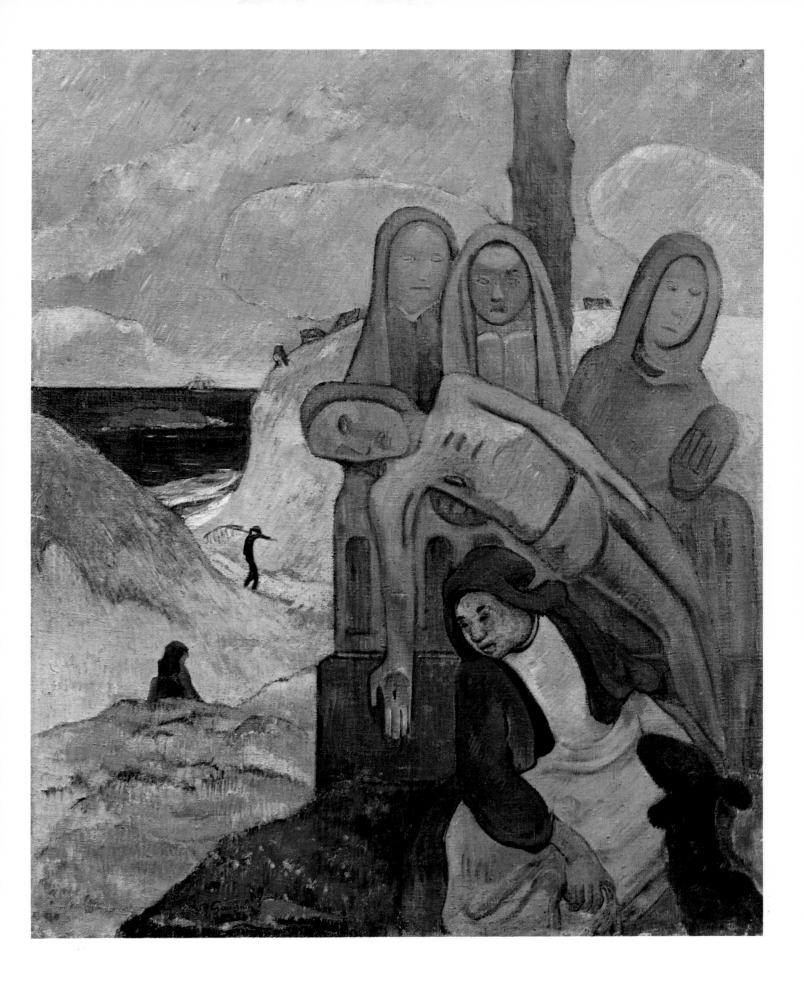

Christ in the Garden of Olives

1889. Oil on canvas, 73 x 92 cm. West Palm Beach, Norton Gallery of Art

Fig. 20
Letter from Gauguin to Van Gogh, with sketch of 'Christ in the Garden of Olives'

When Van Gogh received a sketch and description of this work from Gauguin (Fig. 20) he wrote to Theo about the work of Gauguin and Bernard, who '...have maddened me with their Christs in the Garden, with nothing really observed. Of course, with me, there is no question of doing anything from the Bible - and I have written to Bernard and Gauguin too that I considered that to think, not to dream, was our duty, so that I was astonished looking at their work that they had let themselves go so far...'

Gauguin has returned to a scene from Christ's Passion, chronologically preceding that of the *Green Christ* (Plate 21) and the *Yellow Christ* (Plate 20), in which his isolation and impending martyrdom are made apparent by the gloomy tonality against which his flaming hair glows, and by an all-encompassing landscape which heightens the sense of alienation. Once again, the identification of the artist with Christ is too overt to be overlooked.

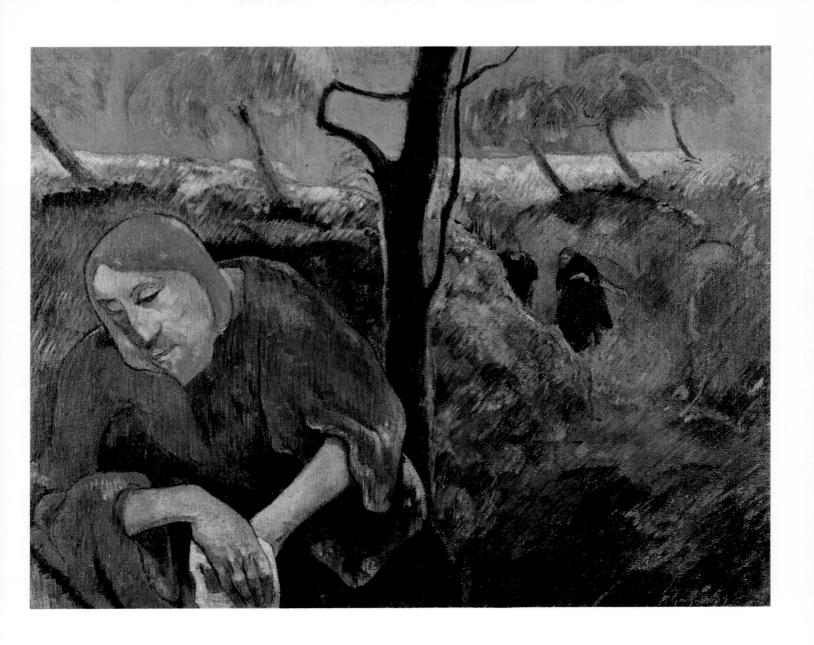

23 Caribbean Woman with Sunflowers

1889. Oil on canvas, 64 x 54 cm. New York, Private Collection

In October 1889 Gauguin returned to Le Pouldu, where he stayed at the inn of Marie Henry with Meyer de Haan. Shortly after their arrival, they began to decorate the inn's dining room and this work was one of the panels Gauguin produced. It hung above the entrance doorway with a second version of *Bonjour Monsieur Gauguin*. The work's decorative purpose meant that Gauguin could capitalize on the heavily stylized forms, bold colours and abstract patterns which he had used in earlier works. The hieratic figure of the woman is a deliberate attempt to make reference to the kind of non-Western art that Gauguin had seen earlier that year at the Exposition Universelle in Paris, where he was particularly influenced by the art in the French colonial section. In fact, the pose of the woman is borrowed from a photograph of the Javanese temple at Borobudur, and was to reappear in later Tahitian works, including *Ia Orana Maria* (Plate 31) which, like the *Carribean Woman with Sunflowers* makes no attempt at authenticity but rather combines cultural references in the desire to evoke not so much a pantheistic vision as a deliberately 'savage' and 'primitive' flavour, which Gauguin was increasingly failing to discover in Brittany.

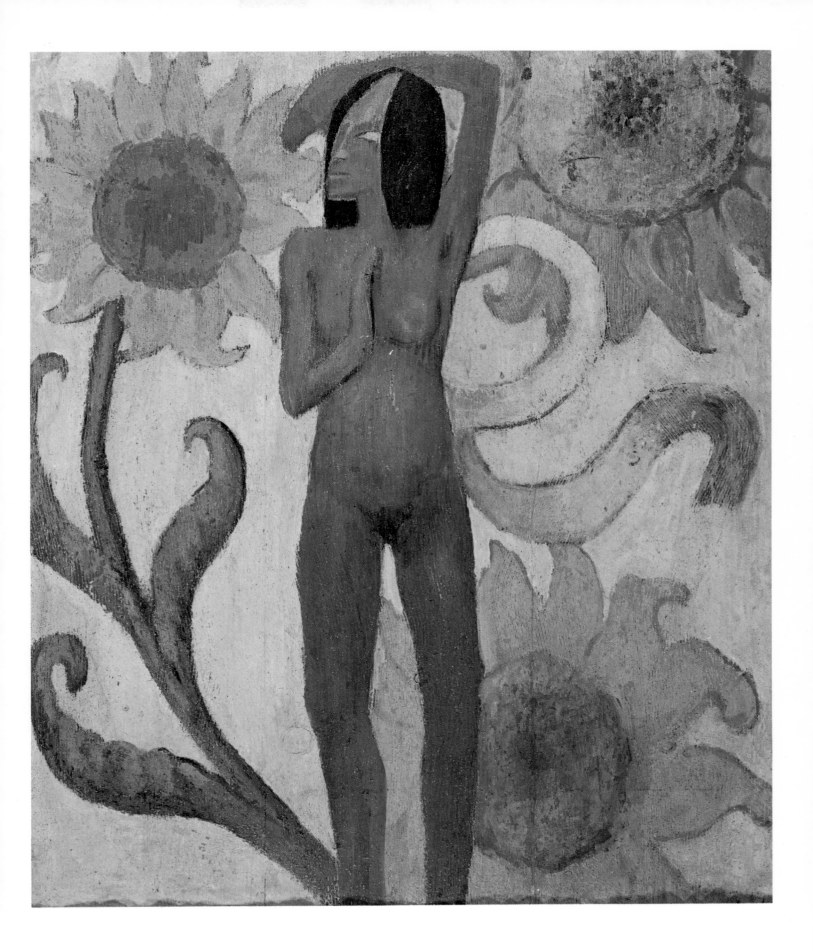

Self-Portrait with Halo

1889. Oil on canvas, 79.2 x 51.3 cm. Washington DC, National Gallery of Art (Chester Dale Collection)

Part of the suite of decorative panels for the dining room of Marie Henry, along with the *Caribbean Woman with Sunflowers* (Plate 23), this work formed the door of a cupboard with a portrait of Meyer de Haan opposite. These two works need to be read as a pair in order to appreciate the wealth of symbols they embody.

Gauguin's head emerges from simplified yellow angel wings, which contrast with the red background, symbolizing the demonic side of his character. The apples and serpent are references to the garden of Eden, to temptation and to Milton's *Paradise Lost* (the book was included in his portrait of Meyer de Haan). The sexual allusion of the apples may have been incorporated for more personal reaons - as a symbol of Gauguin's jealousy at Meyer de Haan's love affair with Marie Henry. Once again, Gauguin has freely plundered different cultural traditions in the interests of a strikingly bold, essentially decorative work, combining Christian iconography with the treatment found in Japanese prints.

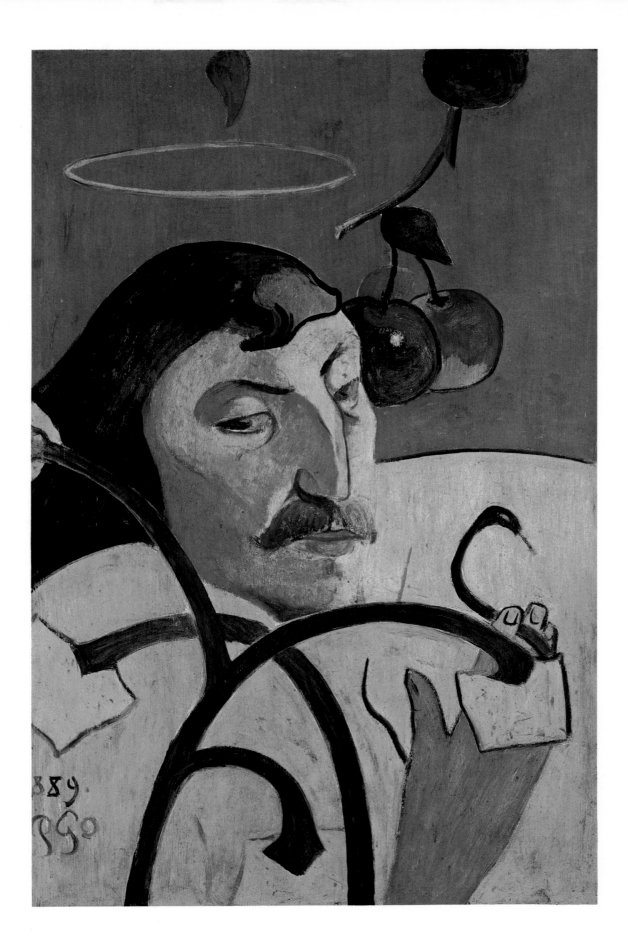

The Seaweed Harvesters

1889. Oil on canvas, 87.5 x 123 cm. Essen, Folkwang Museum

In a letter to Van Gogh, Gauguin described this work which was produced at Le Pouldu in December 1889: 'At the moment, I am working on a painting of women gathering seaweed on the beach. I have pictured them like boxes rising by steps at regular distances, in blue clothes and black coifs despite the biting cold. The seaweed they are collecting to fertilize their land is ochre, with tawny highlights. The sand is pink, not yellow, probably because it is wet, and the sea is a dark colour. I see this scene every day and it is like a gust of wind, a sudden awareness of the struggle for life, of sadness, and of our obedience to the harsh laws of nature. It is this awareness that I have tried to put on canvas, not haphazardly but methodically, perhaps by exaggerating the rigidity of some of the women's poses and the darkness of some of the colours. All this may be mannered to some extent, but on the other hand is there anything about a painting that we can really call natural? Since the very earliest times, everything about painting has been utterly conventional...'

The painting is a blend of fidelity to nature (he paints the sand pink, as he perceives it, rather than the yellow one would expect it to be) and of careful planning, with preparatory studies. At the same time, he recognized that he was still working within certain well-established conventional norms - the distortion of the limbs and the exaggeration of the hands to suggest the tedium of physical labour, something that he could have observed in the representations of peasant life in the work of Millet (Fig. 21) or Van Gogh.

Fig. 21
Jean-François Millet
The Gleaners
1857. Oil on canvas, 83.5 x 111 cm. Paris, Musée d'Orsay

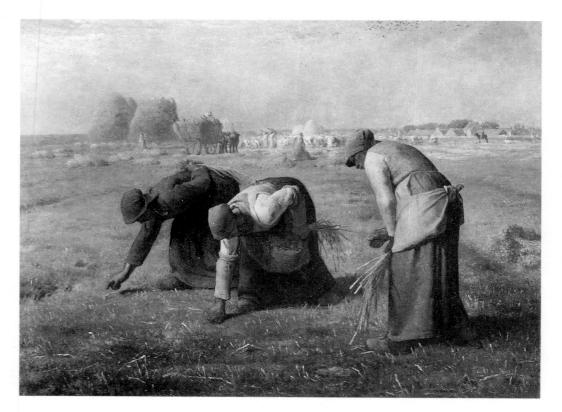

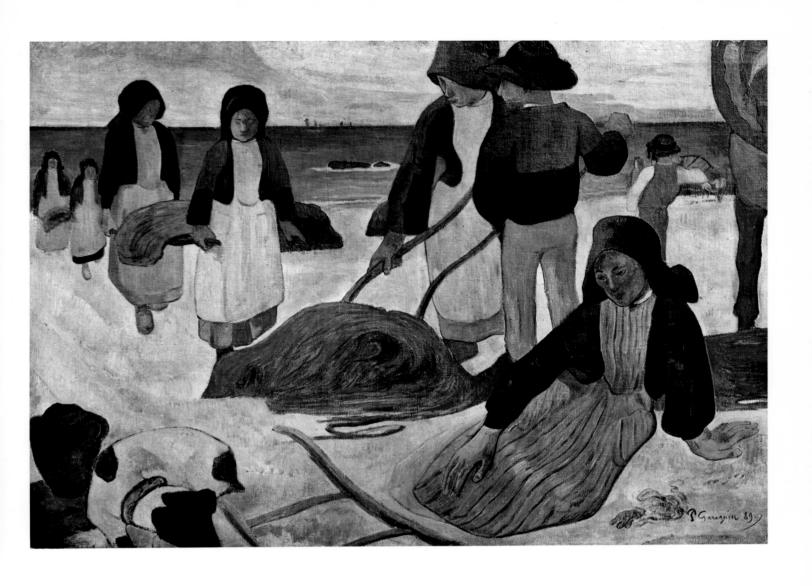

26 The Ham

c.1889. Oil on canvas, 50 x 58 cm. Washington DC, The Phillips Collection

The subject of this still life may have been influenced by a similar work by Manet, painted in the mid-1870s, which Gauguin would have seen at the home of his friend Degas, from 1888. (The work is now in the Burrell Collection, Glasgow.) Still-life painting had been practised by Gauguin throughout his career, often when a model was unavailable. He owned a fine example by Cézanne, the *Still Life with Compotier* (Fig. 13), which he incorporated into the back of a work at this time, the so-called *Portrait of a Woman with Still Life by Cézanne* (Fig. 24).

Gauguin's work shows a marked break with the conventions of French still-life painting, established in the eighteenth century by Chardin, in which the textures and colours of the foodstuffs depicted were exploited for their sensuous qualities (Fig. 22). In contrast, he has refined the objects, simplifying them as far as possible, juxtaposing the arabesques of the table-top and the ham with the verticals of the wallpaper behind.

Fig. 22
Jean Baptiste Chardin
The Tea Pot
1764. Oil on canvas, 32.5 x 40cm. Boston, Museum of Fine Arts

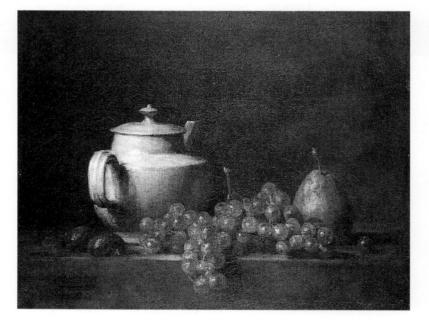

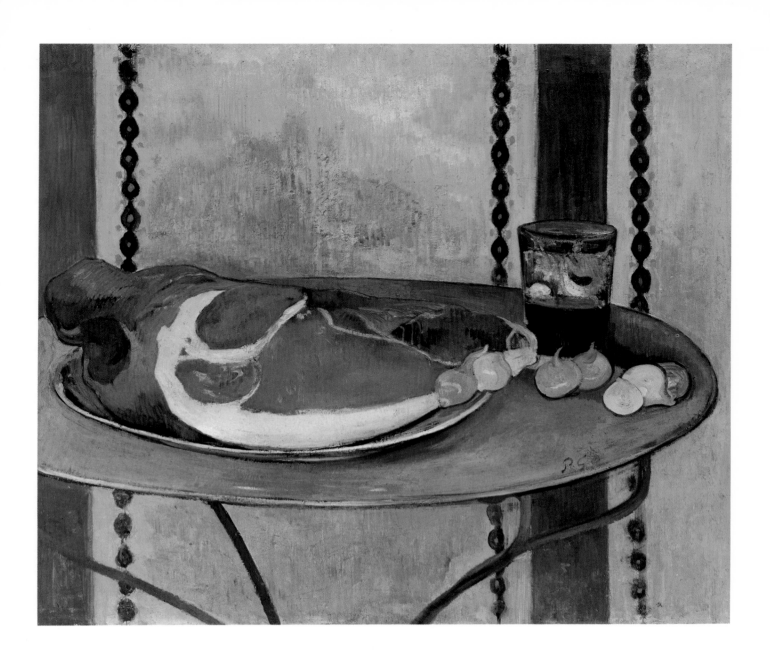

The Loss of Virginity (The Awakening of Spring)

1891. Oil on canvas, 90 x 150 cm. Norfolk, Virginia, the Chrysler Museum

This was Gauguin's last major work produced before he left for Tahiti at the beginning of April 1891. Although it depicts a Breton scene - the figures in the background are often thought to be an ironical depiction of a wedding party - the work was produced in Paris, using Gauguin's 20-year old mistress, Juliette Huet, whom he left pregnant with his child when he went to Tahiti. The obvious precedent for the reclining female nude was Manet's *Olympia* (Fig. 23), which had finally been bought by the French state.

The work is a deliberate attempt at a symbolist painting, produced to appeal to the literary figures who were Gauguin's main supporters at this time. As such, the work is rather laboured in its use of symbolism, in which rather than creating a mood as was more customary, Gauguin has proceeded by a series of easily discernible visual clues. The fox, for example, with his hand on the woman's breast, is both demonic and lubricious, and the red-tipped cyclamen is a reference to the girl's recent defloration.

Fig. 23
Edouard Manet
Olympia
1863. Oil on canvas, 130.5 x 190cm. Paris, Musée d'Orsay

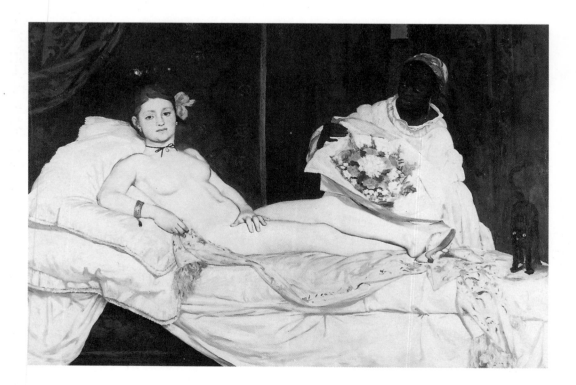

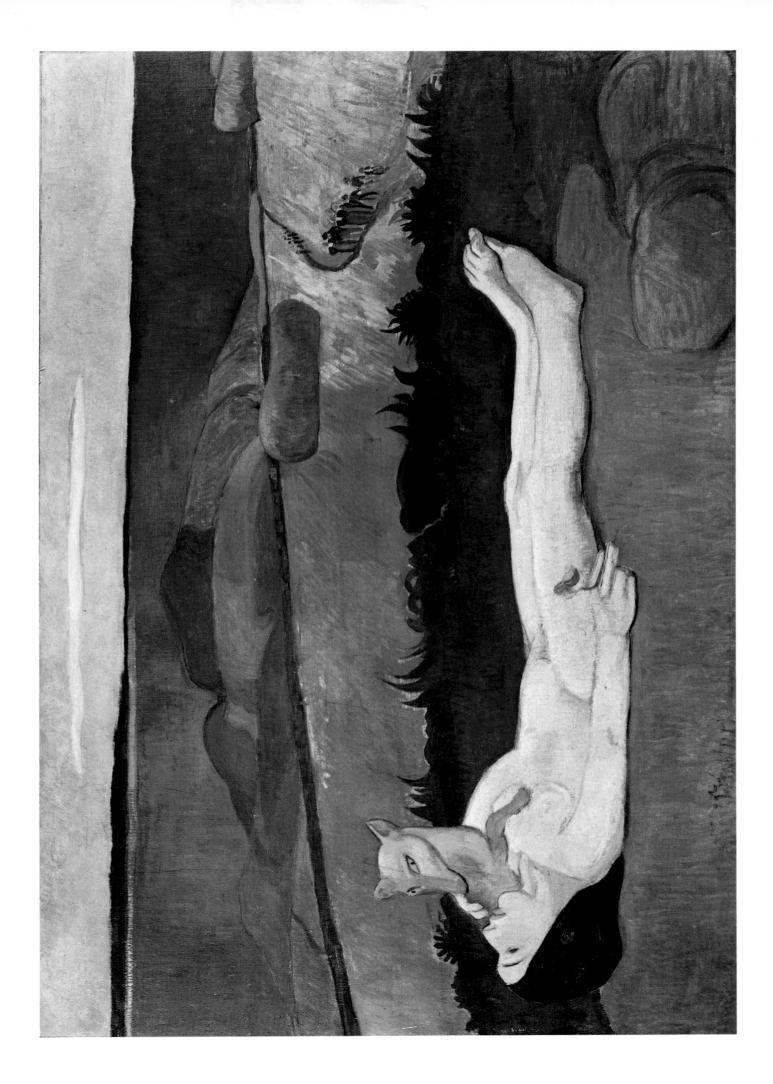

28 Vahine no te Tiare (Woman with a Flower)

1891. Oil on canvas, 70 x 46 cm. Copenhagen, Ny Carlsberg Glyptothek

Gauguin's disappointment, on his arrival in Papeete, at the effects of colonization which had turned the capital of Tahiti into a Europeanized shanty town, meant that in September he moved to Mataiea, 45 kilometres from the centre, where he painted this work.

This is his first major Tahitian portrait, and his model was apparently so overcome at sitting for the artist that she insisted on wearing her Sunday best. The dress that she wears demonstrates the effects of European colonization on the native Tahitians. Women were gradually abandoning the traditional *pareo* in favour of the less revealing Westernized dresses which the Christian missionaries encouraged them to wear. Once again, the idyllic existence that Gauguin sought had already been corrupted by Western influences.

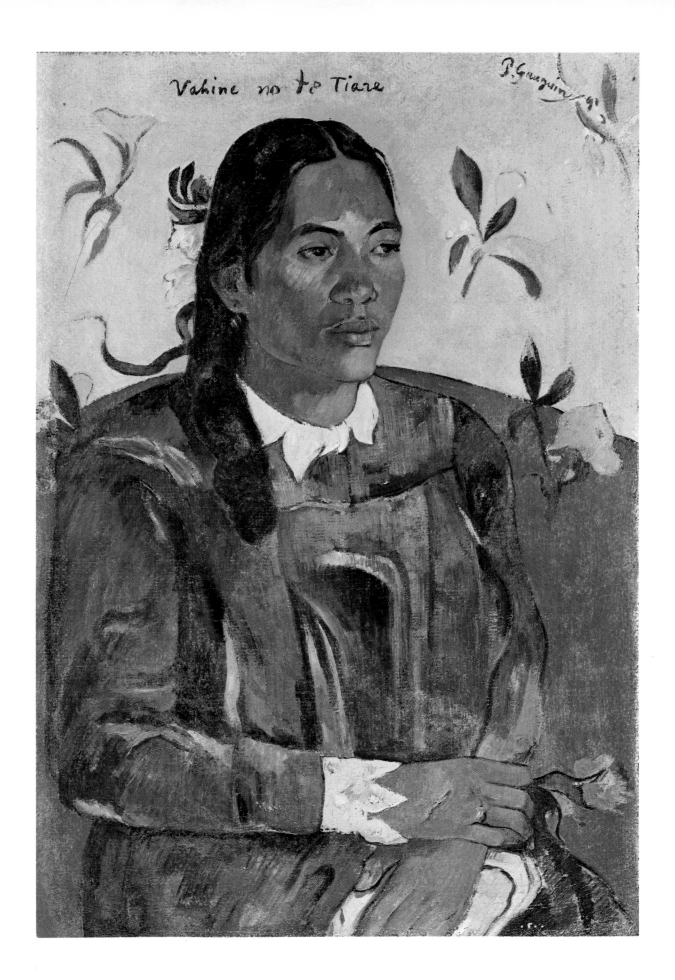

29 Faaturuma (Reverie)

1891. Oil on canvas, 92 x 73 cm. Kansas City, the Nelson-Atkins Museum of Art

The subject for *Faaturuma* may be Tehamana, Gauguin's *vahine* in Mataiea. The domestic setting, with the painting on the wall, Gauguin's rocking chair which he brought from Papeete and the prominent ring suggest that this may be the nineteenth-century equivalent of a betrothal painting.

The subject of the pensive woman had a long pedigree in Western art, and Gauguin has grafted this onto a Tahitian model. The first figure paintings that he produced in Tahiti (including *Vahine no te Tiare*, Plate 28) suggest that he was disappointed at the lack of any remaining authentic Polynesian culture on which to draw for his work, and he attempted a fusion of Western conventions and Tahitian models. It was only after reading Moerenhout in 1892 that his work capitalized on the Tahitian myths and legends that Western colonization and missionaries had effectively destroyed.

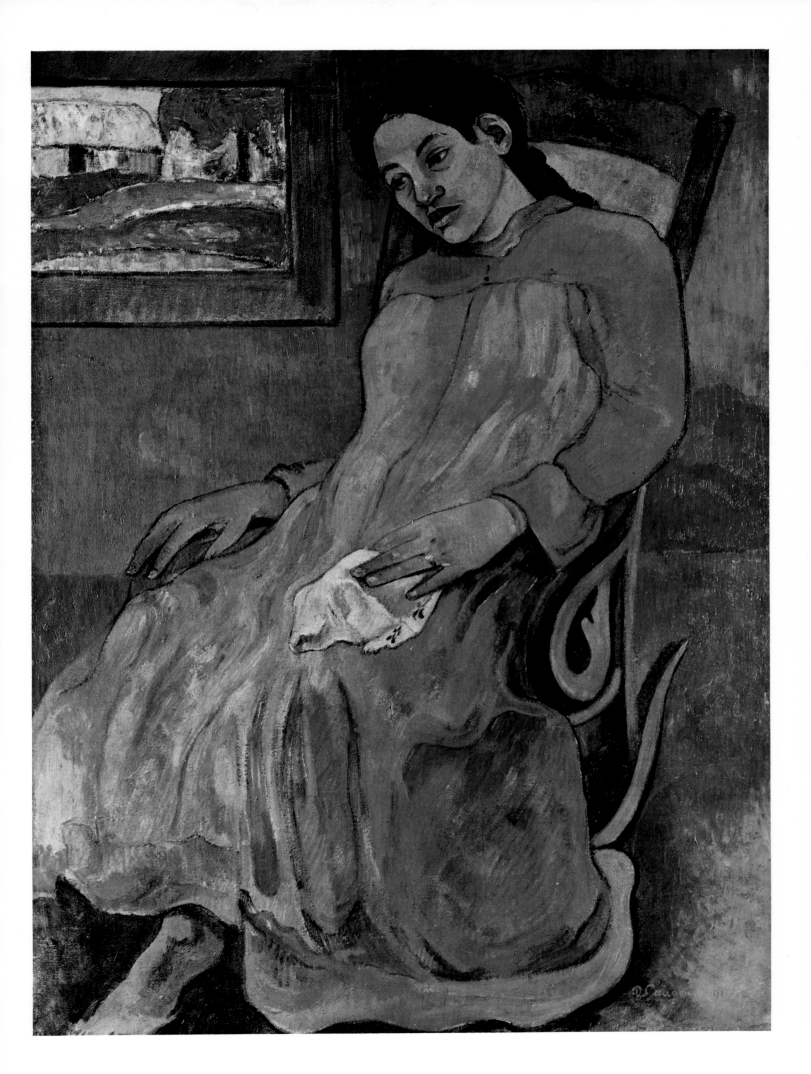

The Meal (The Bananas)

1891. Oil on canvas, 73 x 92 cm. Paris, Musée d'Orsay

Fig. 24
Portrait of a Woman with Still Life by Cézanne
1890. Oil on canvas, 61.6 x 51.4 cm. Chicago,
Art Institute

It was only at a relatively late stage in this work's development that Gauguin transformed it from a simple still life of Tahitian fruit to a genre scene, by including the heads of the three children, together with a view out of a doorway in the background. The configuration of the objects, the use of the large open bowl, together with the white cloth and the knife, is remarkably similar to the objects in the still life by Cézanne that Gauguin owned (Fig. 13). Although he did not have the work with him in Tahiti, he had copied it in the background of *Portrait of a Woman with Still Life by Cézanne* (Fig. 24) the previous year, and a memory of the French work clearly lingered in this painting.

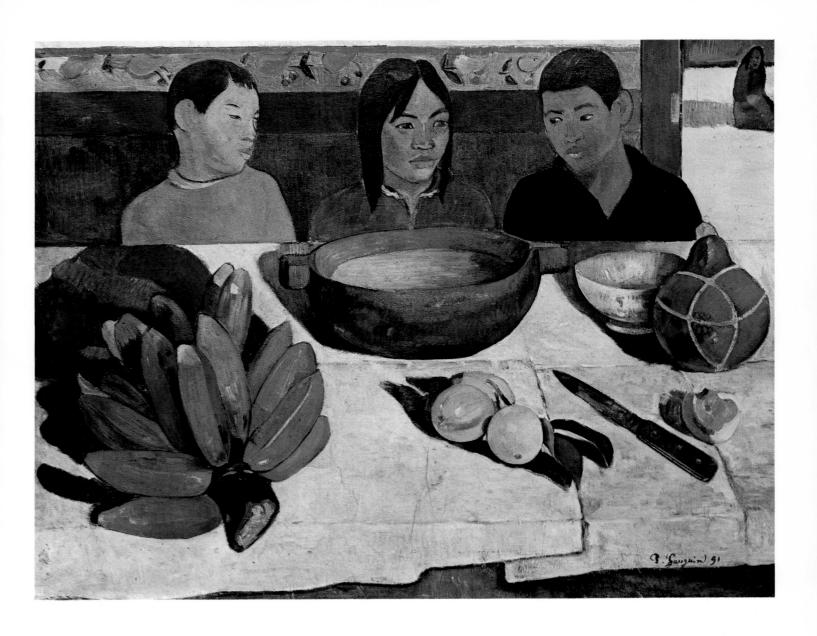

31 Ia Orana Maria (Hail Mary)

1891. Oil on canvas, 114 x 89 cm. New York, Metropolitan Museum of Art

In a letter of 11 March 1892 Gauguin described this highly finished canvas to his friend Daniel de Monfreid, who was responsible for the display and sale of his works in Paris: 'An angel with yellow wings reveals Mary and Jesus, Tahitians just the same, to two Tahitian women, dressed in *pareos*, a sort of cotton cloth printed with flowers...very sombre mountainous background and flowering trees. Dark violet path and emerald green foreground, with bananas on the left. I am rather happy with it.'

Once again he has returned to the theme of the effect of profound religious faith on an apparently simple people, which had preoccupied him in some of his most important Breton works. The apparently effortless fusion of Christian iconography with Tahitian subject matter is in fact carefully contrived, with the poses of the background figures lifted from the relief carving on the Javanese temple of Borobudur, photographs of which Gauguin had taken with him to Tahiti.

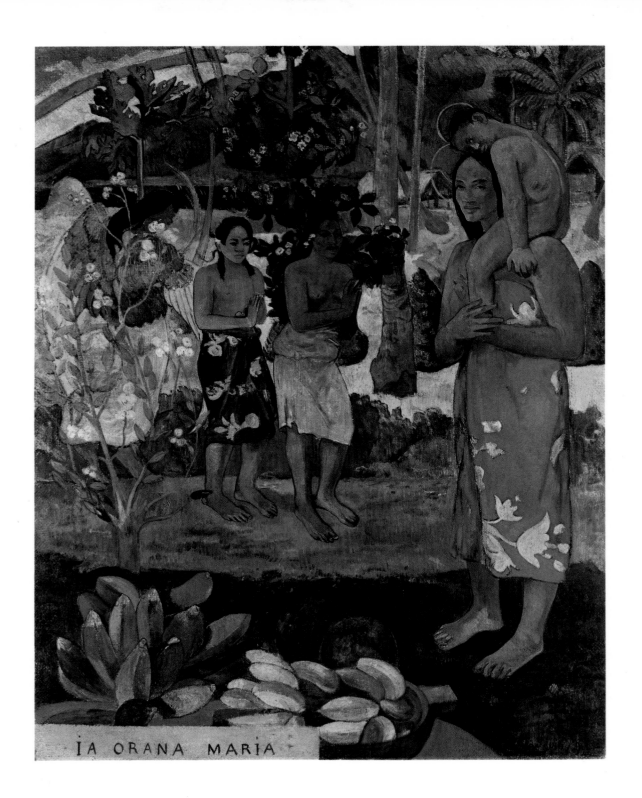

Nafea Faa Ipoipo (When Will You Marry?)

1892. Oil on canvas, 101.5 x 77.5 cm. Basel, Kunstmuseum

When Gauguin included this painting in the exhibition he mounted at Durand-Ruel's gallery back in Paris in 1893, its price of 1500 francs was higher than that of any other work included in the show, demonstrating the importance he attached to it. Because of its exoticism it was a work that was guaranteed to appeal to a Parisian audience, and Gauguin's careful inscription of the title onto the painting points to his control of his audience. The question seems to be posed by the woman in the background, of her companion whose desire to find a husband is suggested by the flower she is wearing behind her ear. That it should deal with the ritual surrounding Tahitian marriage was a clear attempt to appeal to an audience who would have recognized the subject of the eminently popular *Marriage of Loti*, which Gauguin had read and which helped shape contemporary Western perceptions about the languorous Tahitian women.

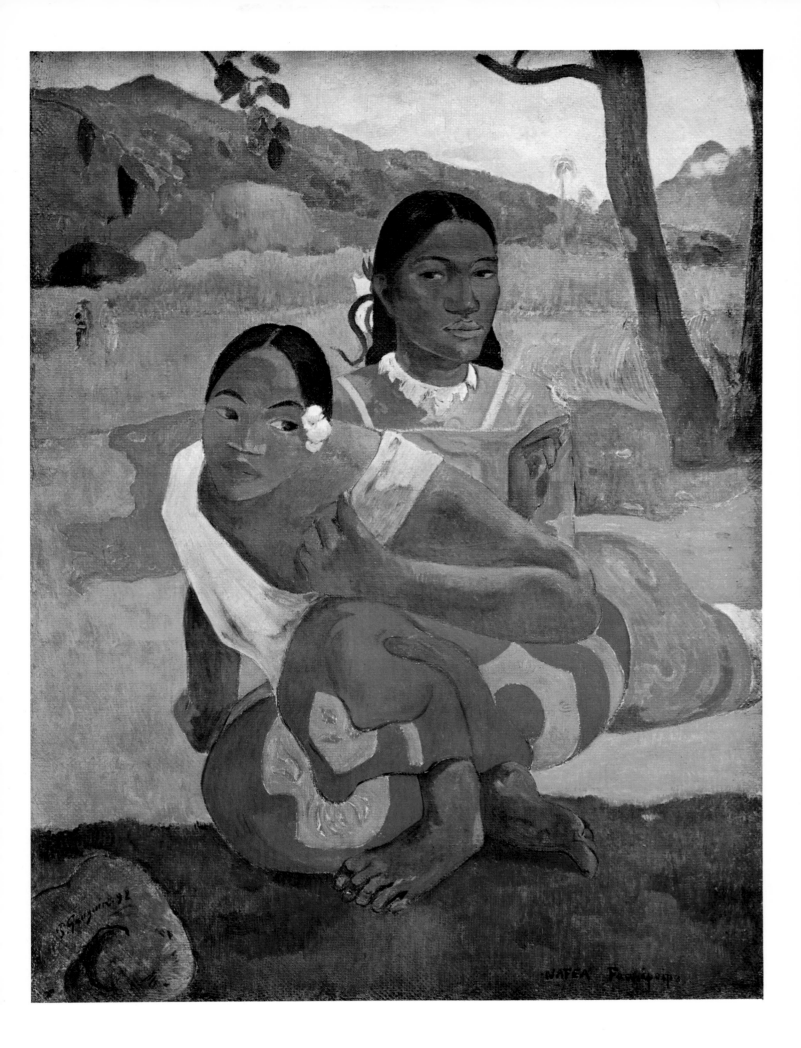

33 Manao Tupapau (The Spirit of the Dead Keeps Watch)

1892. Oil on canvas, 73 x 92 cm. Buffalo, Albright-Knox Art Gallery

The inspiration for *Manao Tupapau* was two-fold: a free adaptation of Manet's *Olympia* (Fig. 23) which Gauguin had copied in 1891, and his reading of J.-A. Moerenhout's *Voyages aux Iles de Grand Océan* in 1892. This work chronicled Polynesian customs and ritual, which by the time of Gauguin's arrival in Tahiti had largely vanished, mainly due to Western colonial interference. This work, first published in 1837, was the inspiration for Gauguin's *Noa Noa* which he began writing on his return to Paris in 1893. *Noa Noa* included a description of *Manao Tupapau*, but it is perhaps the notes he wrote to Mette, who organized its exhibition in Copenhagen in 1893, that best capture the flavour of the work: 'I have painted a young girl in the nude. In this position, a trifle more, and she becomes indecent. However, I want it in this way as the lines and movement interest me. So I must make her look a little frightened... This people have, by tradition, a great fear of the spirit of the dead... There are some flowers in the background, but they are not real, only imaginary, and I make them resemble sparks. The Kanaka believe the phosphorescences of the night are the spirits of the dead and they are afraid of them. To finish, I make the ghost only a good little woman, because the young girl...could not visualize death itself except as a person like herself...To end, the painting has been done quite simply, the motive being savage, childlike.'

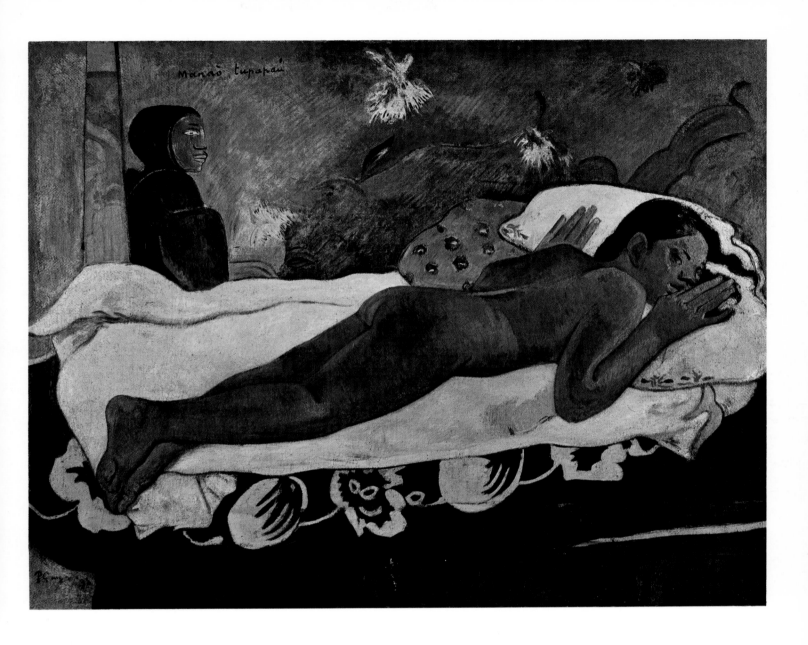

Ta Matete (The Market)

1892. Oil on canvas, 73 x 92 cm. Basel, Kunstmuseum

In the absence of any remaining native culture in Tahiti, Gauguin gradually began to create a convincing fiction of life in a tropical paradise from an eclectic range of sources. After reading Moerenhout he constructed some notion of a mythical past, and from a wide selection of photographs and illustrations that he took with him to Tahiti he imposed the cultures of so-called primitive peoples onto Tahitian subject matter in an attempt to make it look authentically 'savage'. In *Ta Matete* the poses of the figures derive from an Egyptian fresco painting on a Theban tomb that Gauguin had seen in the British Museum. In the work, he has retained the insistent frieze-like composition of his source, observing each of the women full-face or in rigid profile.

The work represents the prostitutes who frequented the market place in Papeete, in response to the demands of the colonial population. Gauguin's retention of the hieratic gestures of the original may be an ironic comment on the constrained sexuality of the native Tahitians, forced to pander to a Western audience.

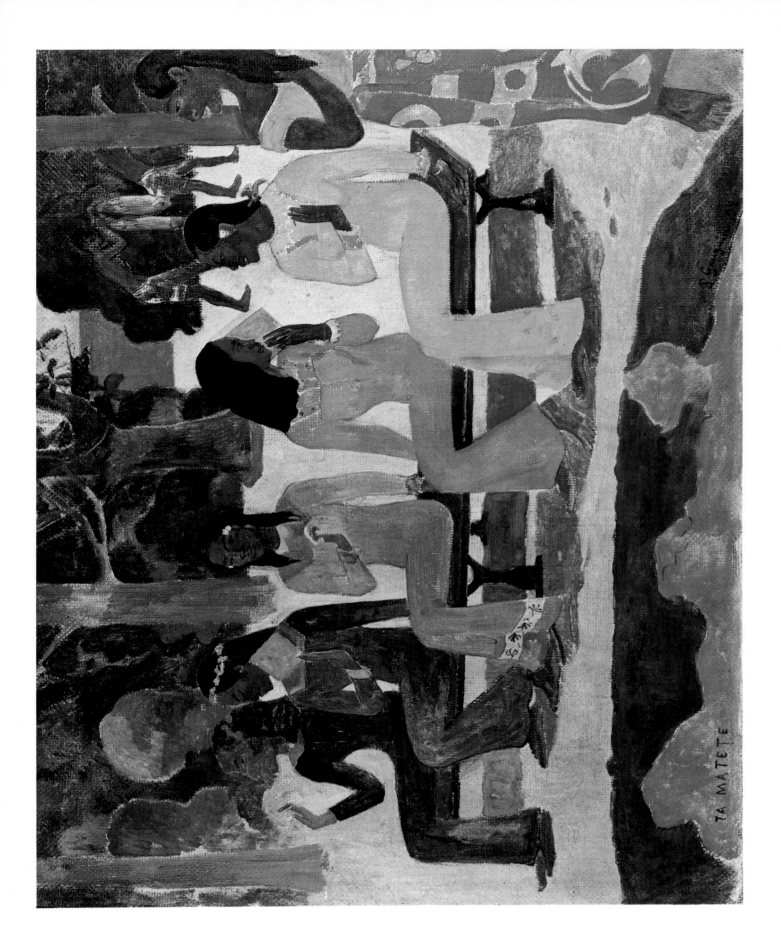

Fatata te miti (Near the Sea)

1892. Oil on canvas, 68 x 91.5 cm. Washington DC, National Gallery of Art (Chester Dale Collection)

In 1889 Gauguin had painted a pair of works entitled *Women Bathing (Life and Death)* and *Woman in the Waves (Ondine).* The latter (in the Cleveland Museum of Art) depicts a naked woman, seen from behind, cast adrift in the waves, and in *Fatata te miti* he has reused the same subject, setting her within a Tahitian genre scene. In *Ondine*, Gauguin had treated the myth of the water-sprite who can only become human after having a child fathered by a man. Once again, he has explored the theme of the joy of sexual union as an essentially liberating activity, hinted at in the alternative title for *The Loss of Virginity: The Awakening of Spring* (Plate 27). In *Fatata te miti* the sexual abandonment is seen as part of the natural rhythm of Polynesian life (the two women do not appear perturbed at the presence of the fisherman in the background of the work), a notion that was integral to the highly popular *Marriage of Loti*, which Gauguin had read before visiting Tahiti and which was calculated to appeal to a Parisian audience.

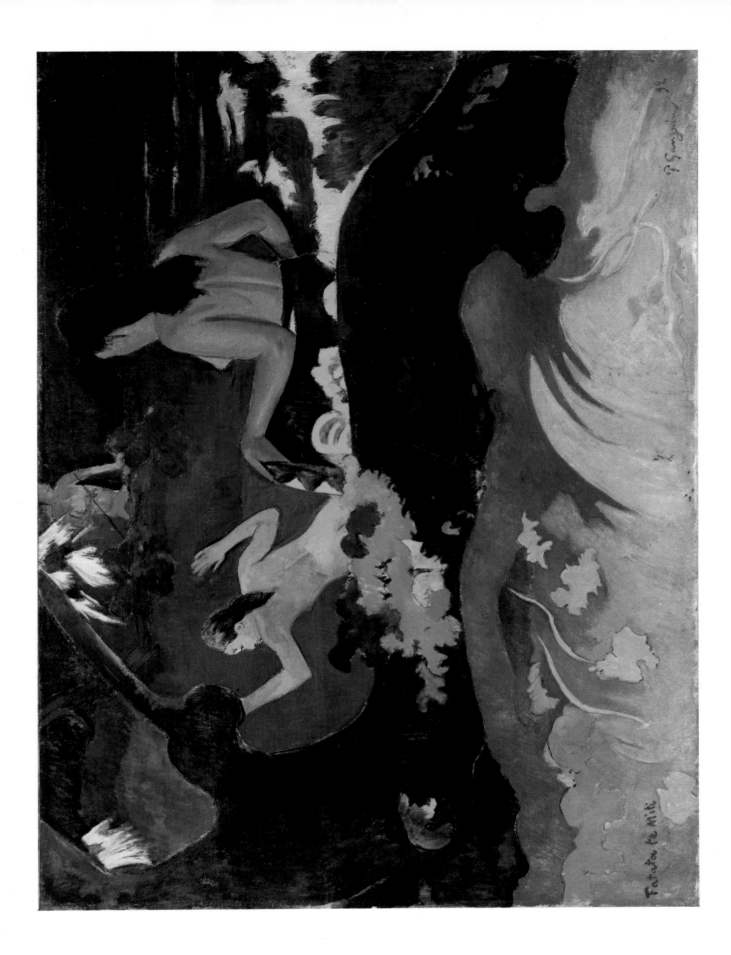

36 Tahitian Pastorals

1892. Oil on canvas, 86 x 113 cm. Leningrad, State Hermitage Museum

In a letter to his friend Daniel de Monfreid in Paris, written in December 1892, Gauguin described this work and two smaller canvases: 'I believe they are my best, and since it will be the first of January in several days I have dated one, the best, 1893. Exceptionally, I gave it a French title: *Pastorales Tahitiennes*, not finding a corresponding title in the language of the South Seas.'

The importance of titles to all the works Gauguin produced in Tahiti should not be overlooked, especially since they were usually written prominently in large letters. These add a further dimension to his paintings and demonstrate his attempts to woo a Parisian audience with whimsical, allusive names that conjure up visions of an idyllic existence, in which the figures roam freely in a strangely timeless setting.

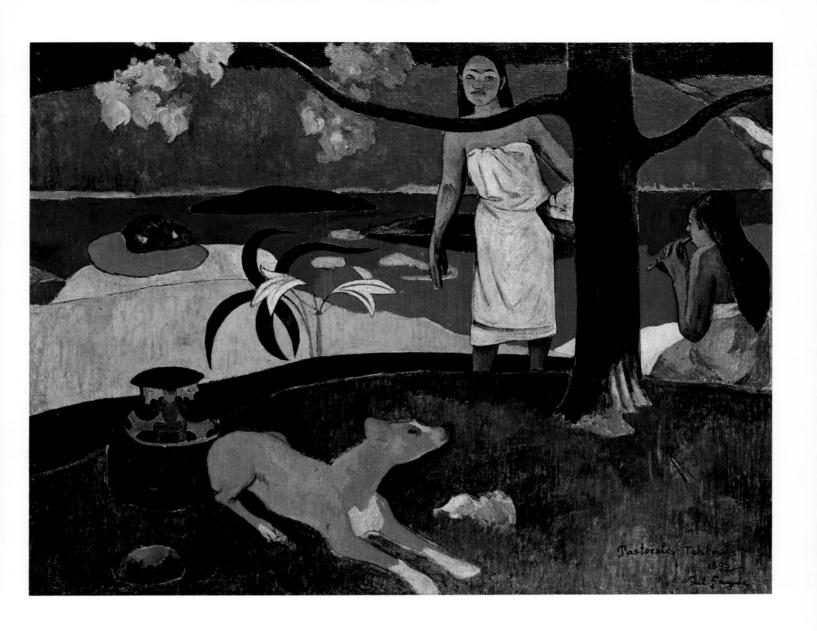

Ea haere ia oe? (Where Are You Going?)

1893. Oil on canvas, 91 x 71 cm. Leningrad, State Hermitage Museum

Despite the prominence and importance of titles in Gauguin's art, their meaning is often far from evident, and there seems to be a degree of capriciousness in their choice. It is far from clear who is posing the question here and indeed why, although the woman's insistent gaze seems to suggest direct communication with the spectator. It is possible that it was posed to the artist himself by the archetypal Tahitian woman, since Gauguin was to leave Polynesia later that year. If that is so, then the ripe exotic fruit she nurses to her breast becomes a symbol of the sensual gratification he will leave behind by going back to French 'civilization'. Quotations from other paintings are included, most notably the crouching maiden from *Nafea faa ipoipo* (Plate 32), who acts as a further reminder of what he will miss.

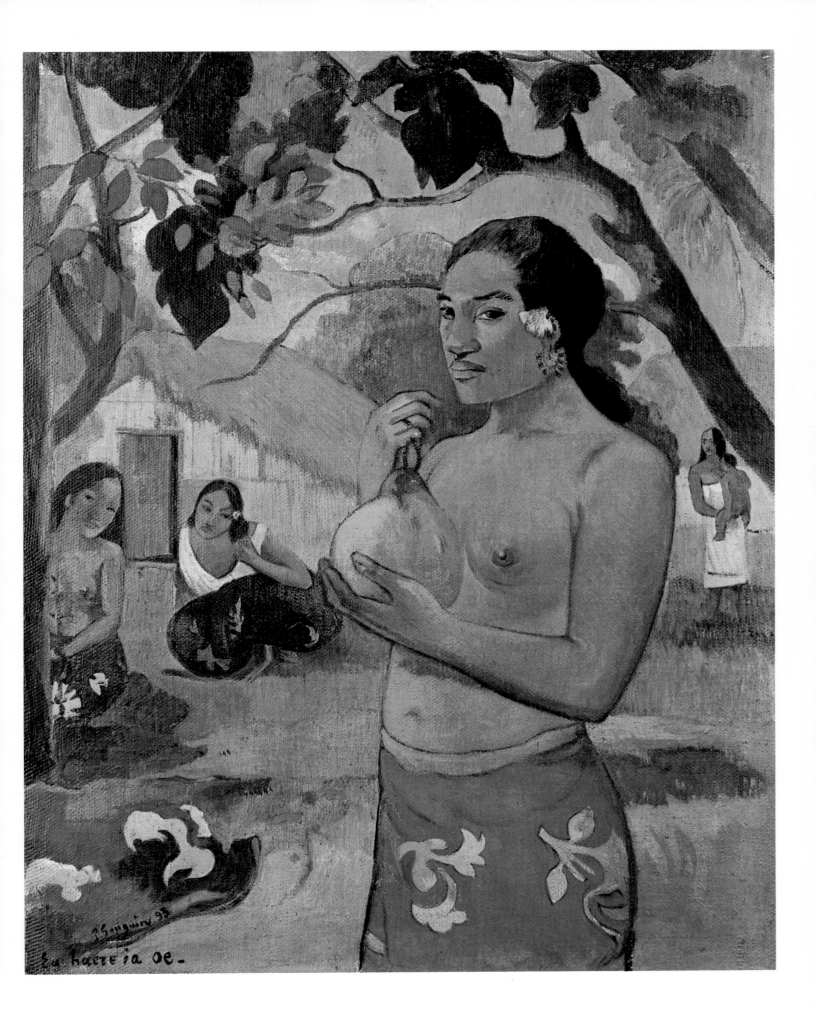

Hina tefatou (The Moon and the Earth)

1893. Oil on canvas, 112 x 61 cm. New York, Museum of Modern Art

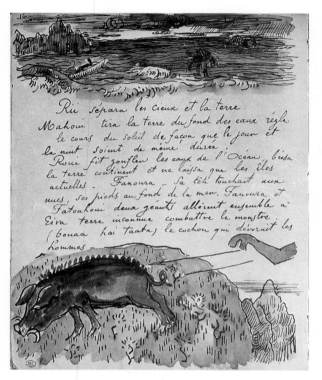

Fig. 25
Page from 'Ancien Culte Mahorie'
Paris, Cabinet des Dessins

Gauguin copied this myth from the pages of Moerenhout into *Ancien Culte Mahorie* and from there into *Noa Noa*, as well as producing this painting and a woodcarving dealing with the same theme. It represents the goddess Hina who pleads with Tefatou to grant mankind immortality. In *Ancien Culte Mahorie* (Fig. 25) Gauguin wrote: 'Hina said to Fatu:"Bring man back to life, or resuscitate him after his death." Fatu replies: "No, I shall not revive him. The earth will die, the vegetation will die, they will die just like the men that they nourish..." Hina replies: "Do as you wish: for my part I will bring the moon back to life. And that which belonged to Hina will continue to live: that which belonged to Fatu will perish, and man must die."'

The painting was included in the exhibition that Gauguin organized at Durand-Ruel's gallery in Paris in November 1893. The works exhibited were his most recent: a few sculptures, three paintings from Brittany and 41 from Tahiti. In the end, only 11 paintings were sold and the artist Degas bought *Hina tefatou*.

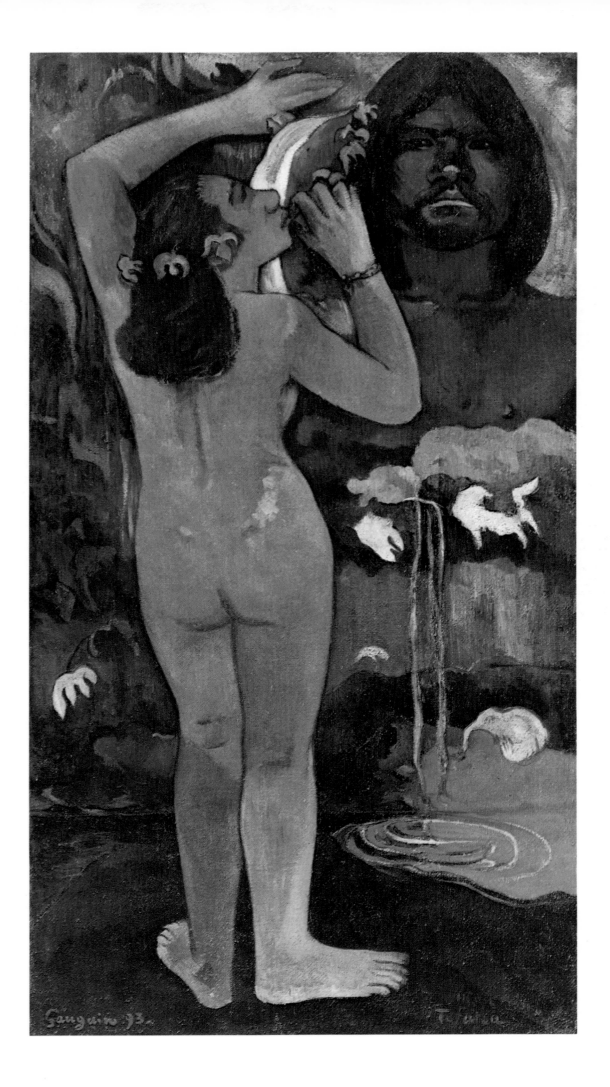

Self-Portrait with a Palette

c.1894. Oil on canvas, 92 x 73 cm. Private Collection

In this self-portrait, the artist has returned to the subject of *Gauguin at his Easel* (Plate 3), which had been painted in 1885 during his stay in Copenhagen. In both, the artist is shown intent on his craft, palette in hand, with a sideways glance. In tenor, however, the later work demonstrates the self-confidence of an artist who had just held a one-man exhibition in a prime Parisian gallery, which in critical terms he had deemed a success; who had the support of the most vanguard Parisian writers; and who had begun to write *Noa Noa* which he intended as a work to 'facilitate the understanding' of his most recent Tahitian paintings.

The work is dedicated to the poet Charles Morice (1860-1919), who collaborated with Gauguin on the writing of *Noa Noa* in 1893-5, which would mean that the work dates from his period in Paris, although it is taken directly from a photograph of 1888.

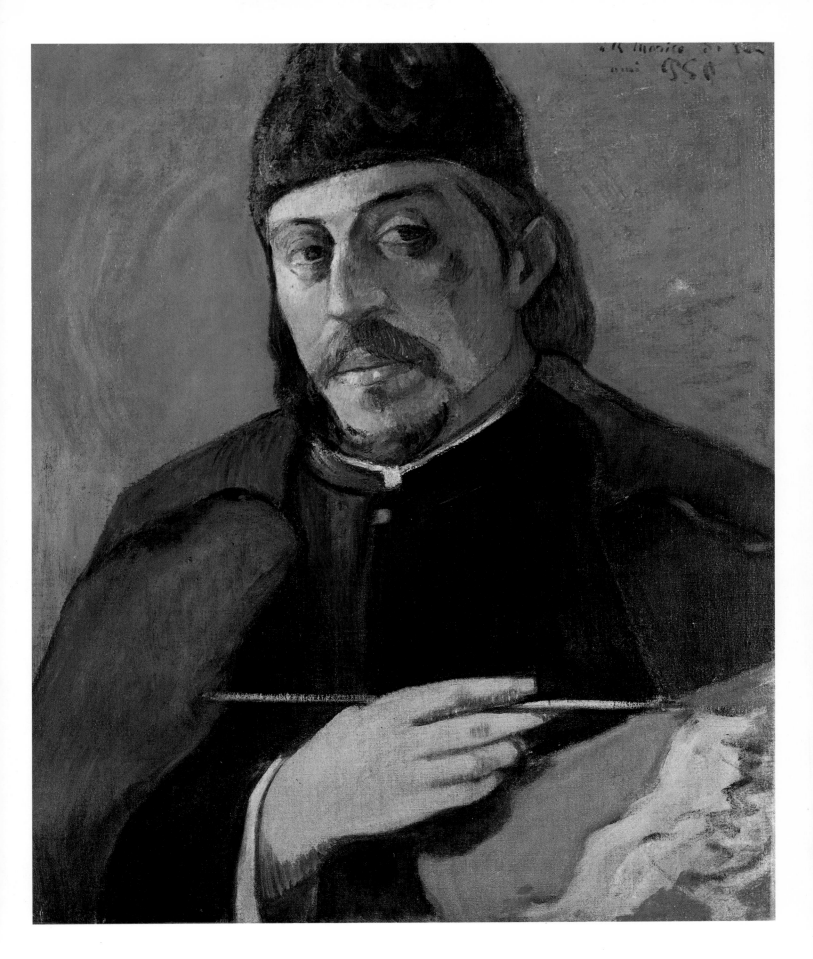

40 Aita tamari vahine Judith te parari (Annah the Javanese)

1893-4. Oil on canvas, 116 x 81 cm. Private Collection

At the beginning of January 1894 Gauguin moved into an apartment on the rue Vercingétorix in Paris which he decorated with chrome yellow walls, hung with his paintings and those remaining works from his collection by other artists, including Cézanne and Van Gogh. It was through the picture dealer Ambroise Vollard that he met the 13-year-old Annah, who moved in with him. Despite her exotic name, she was in fact Singalese. It is generally assumed that this work represents Annah with her pet monkey Taoa.

The Tahitian inscription, which may be translated as 'the child-woman Judith is not yet breached', seems at first to have little relevance to the subject. It has been suggested that this refers to Judith Molard, the daughter of his friend William Molard, who was also 13 years old. Perhaps by depicting Annah with all the sangfroid of Manet's *Olympia* (Fig. 23) and referring to the sexually naive Judith in the title, he is poking fun at the constraints imposed by her bourgeois parents. They, of course, would not have understood the title.

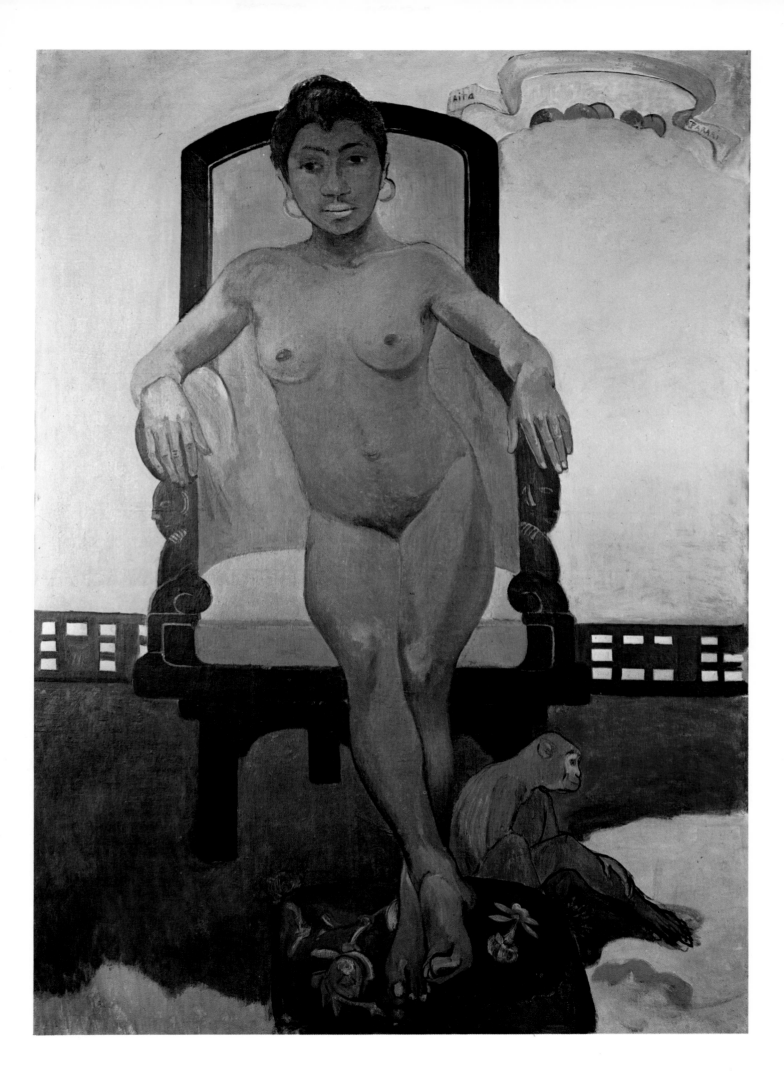

41 Mahana no atua (The Day of the God)

1894. Oil on canvas, 66 x 108 cm. Chicago, Art Institute (Helen Birch Bartlett Collection)

In the two years that Gauguin spent in Paris between his trips to Tahiti he was occupied with a number of different projects, including the exhibition of his recent work at Durand-Ruel's and the writing of *Noa Noa*. All this left him little time to seek out new motifs, and he fell back on favourite themes in an attempt to consolidate his exotic reputation. *Mahana no atua* was probably painted immediately after his exhibition and represents a fictionalized version of life in Tahiti, akin to that which he was creating for *Noa Noa* which drew largely on J.-A. Moerenhout's *Voyages aux Iles du Grand Océan* (first published in 1837) and which furnished Gauguin with ideas for his writings, paintings and carvings. The figure of the god in the centre of the composition, around which the work revolves, is a composite of Moerenhout's description of figures from Easter Island and those from Borobudur, of which he had photographs. The ritualistic aspect of the scene is enhanced by the use of a frieze-like arrangement of figures and by the work's esoteric nature.

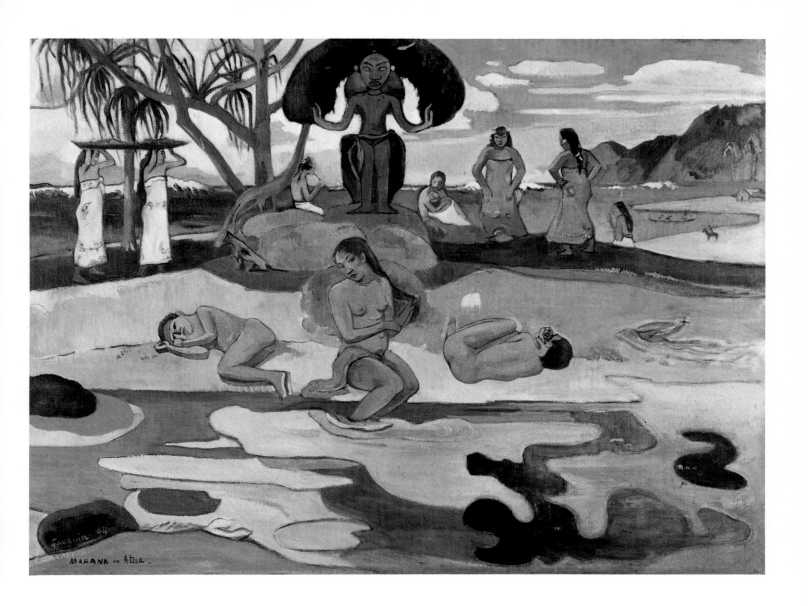

Village under Snow

1894. Oil on canvas, 65 x 90 cm. Paris, Musee d'Orsay

Fig. 26
Gustave Caillebotte
Place de l'Europe on a Rainy Day
1877. Oil on canvas, 212.1 x 276.4 cm.
Chicago, Art Institute

This work was probably produced at the beginning of 1894, when Gauguin painted another snowscape, *Paris in the Snow* (Amsterdam, Rijksmuseum Van Gogh). During his two years in Paris he painted far fewer works than before - large amounts of his time were taken up with organizing his show at Durand-Ruel's and on a number of literary projects. Consequently, what little he did paint was not new in either subject or treatment. This landscape is remarkably similar to those that he had produced during his Impressionist period - the small brush-strokes are quite different from the broad sweeps of colour that characterized his Tahitian works. A revival of Impressionist technique and subject may have been influenced by the Caillebotte bequest to the Luxembourg museum that same year - when the French nation first acquired a major collection of Impressionist paintings (Fig. 26).

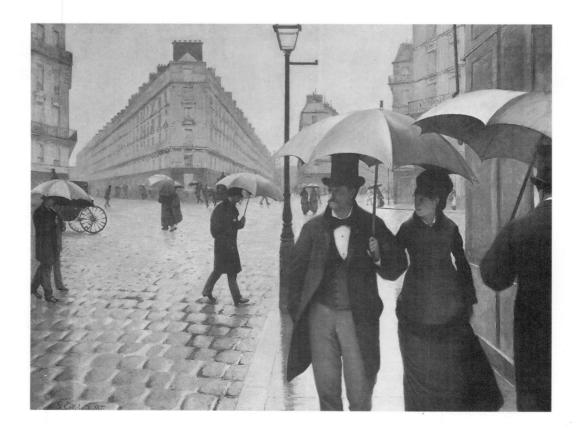

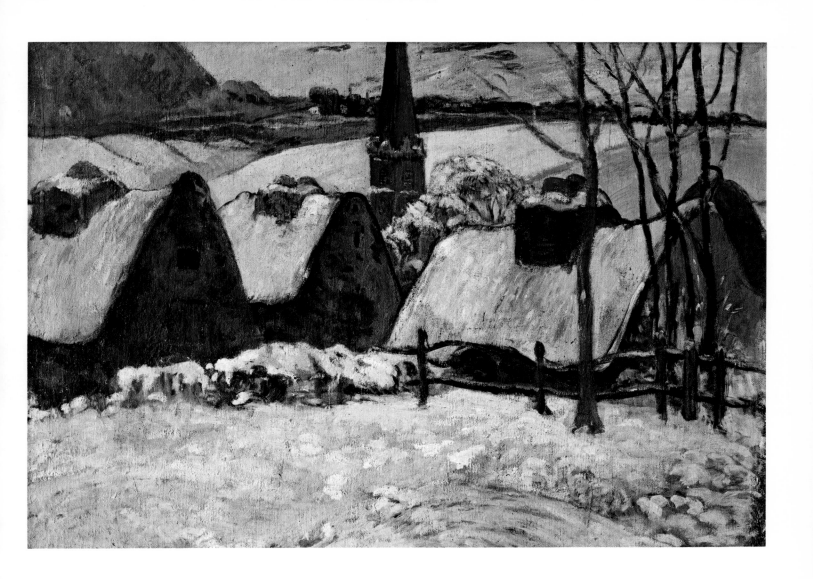

43 Nevermore

1897. Oil on canvas, 60.3 x 116.2 cm. London, Courtauld Institute Galleries

Gauguin wrote to his friend Daniel de Monfreid in Paris on 14 February 1897 describing this work: 'I am attempting to finish a canvas to send with the others, but shall I have enough time?...I don't know if I am mistaken, but I believe it to be good. With a simple nude I wished to suggest a certain long-gone barbaric luxury. It is all drowned in colours which are deliberately sombre and melancholy...for its title, *Nevermore*, not exactly the raven from Edgar Poe, but the bird of the devil which keeps watch. It's badly painted...never mind, I think that it's a good canvas...'

Like *Manao Tupapau* (Plate 33), this work is a free adaptation of Manet's *Olympia* (Fig. 23), which Gauguin had copied before going to Tahiti in 1891. Like his earlier work, *Nevermore* attempts to suggest the superstitious dread of the Tahitian woman who lies alone in the foreground. Although Gauguin denied any association with Edgar Allen Poe's poem *The Raven*, published in 1875, the links are too obvious to be overlooked, particularly since it would have been well-known in the literary circles within which Gauguin moved, and had been illustrated in translation by Manet.

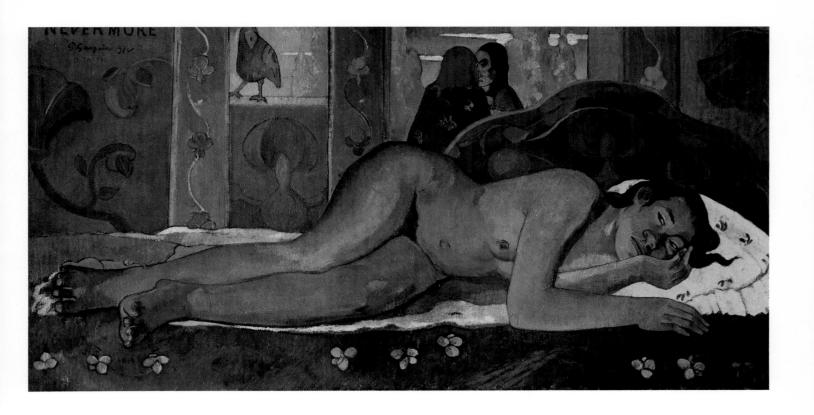

Where Do We Come From? What Are We? Where Are We Going?

1897. Oil on canvas, 141 x 376 cm. Boston, Museum of of Fine Arts (Arthur Gordon Tompkins Residuary Fund)

In a letter of February 1898 to Daniel de Monfreid, Gauguin had written that he had wished to paint a large canvas without the benefit of preparatory sketches, done on rough sackcloth and which had taken him less than a month. After describing the picture at some length, making it clear that the work should be read from the sleeping baby in the bottom right towards the crouching old woman in the lefthand side, he concluded, 'I've finished a philosophical work...I think it very good, if I have the strength to copy it, I shall send it to you.' After its completion, he had then unsuccessfully attempted to commit suicide by swallowing arsenic. For this reason, the painting is often regarded as the summation of Gauguin's career.

However, an intricate and detailed preparatory sketch for the whole work exists (Fig. 27), throwing the story into doubt. Certainly Gauguin had every reason to try to kill himself; he was very ill and had just learned of the death of his favourite child Aline. It is equally characteristic, however, that he might have attempted to consolidate the myth of artistic martyr that he had been creating steadily both in his painting and in his writing. To leave such a major and complex canvas as a last grand flourish would have virtually guaranteed his posthumous artistic reputation back in Paris.

Fig. 27
Sketch for 'Where Do We Come From? What Are We? Where Are We Going?'
1897. Paris, Cabinet des Dessins

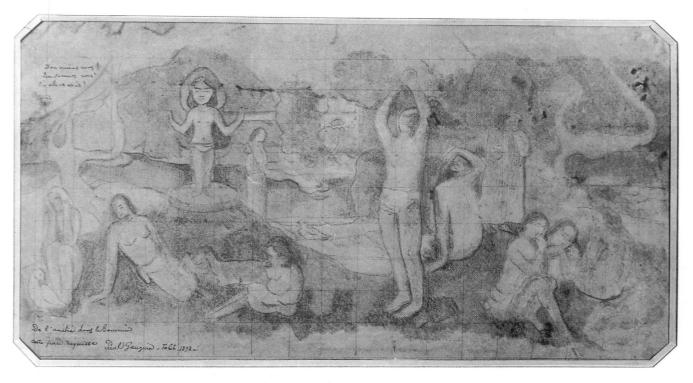

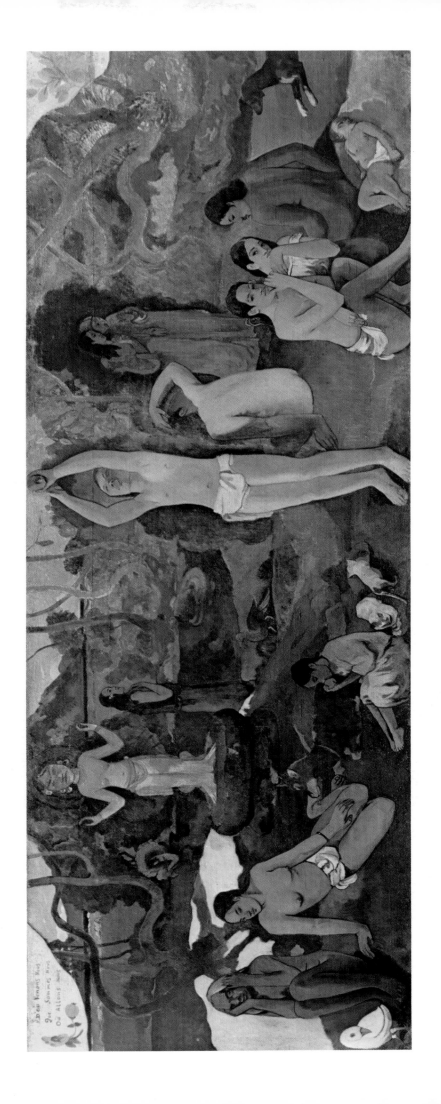

45 The White Horse

1898. Oil on canvas, 141 x 91 cm. Paris, Musée d'Orsay

The horse was a comparatively rare animal in Polynesia, having been introduced from the West in the sixteenth century, but Gauguin has placed these three animals in this tropical eden as if they belonged there quite naturally. The white horse in the foreground lends the work its name, but this title was given to the work by Daniel de Monfreid long after Gauguin's death. It is riderless, but the two animals in the background are mounted. It is difficult to know exactly what Gauguin intended by the work, given the absence of his usual inscribed title, but the lush vegetation, rich colours and naked figures suggest an earthly paradise in which man and nature co-exist quite happily. After he had moved to Hivaoa in 1901, Gauguin returned to the theme of horse and rider, in two works that are clearly influenced by the Parisian racing scenes of Degas (Fig. 28).

Fig. 28
Edgar Degas
Horses on the Course at Longchamp
c. 1873-5. Oil on canvas, 30 x 40 cm.
Boston, Museum of Fine Arts

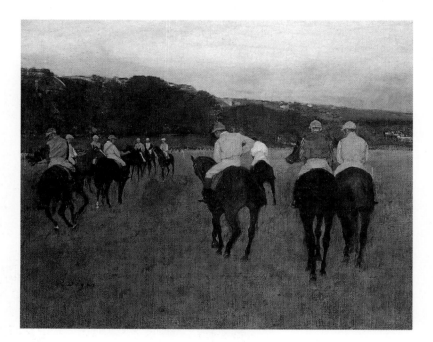

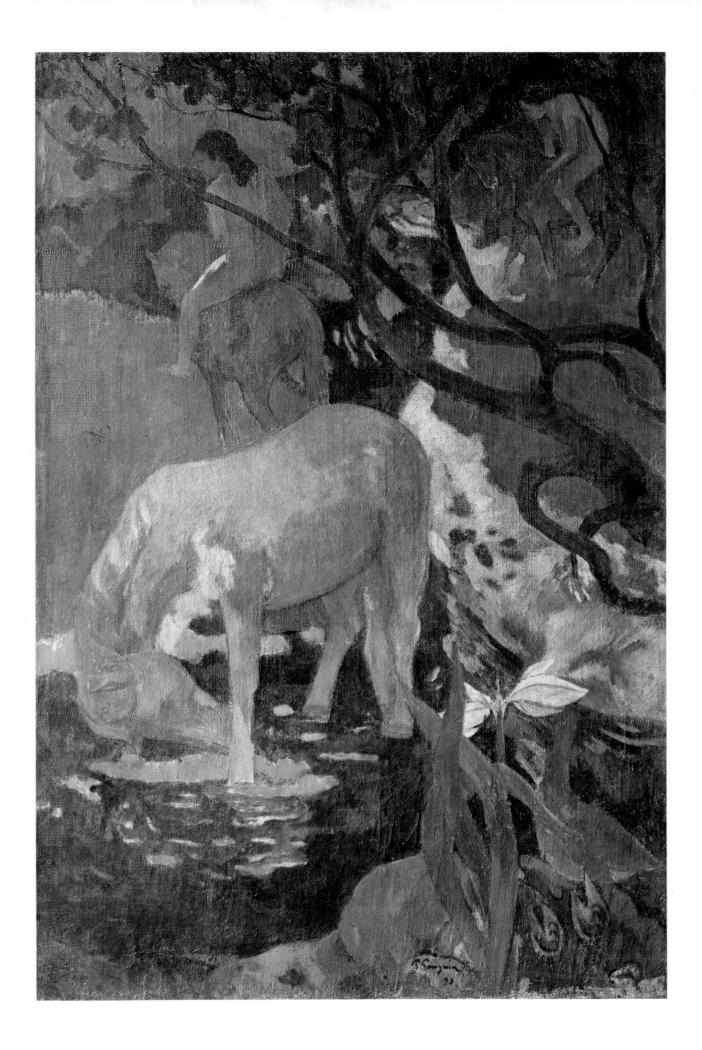

Woman and Two Children

1901. Oil on canvas, 97 x 74 cm. Chicago, Art Institute (Helen Birch Bartlett Collection)

In 1901, when he painted this work, Gauguin finally left Tahiti to go to Hivaoa in the Marquesas. On his arrival, he began building his 'House of Pleasure' in the town of Atuona, and his output decreased significantly at this time. Much of what he produced was reworkings of old themes, and *Woman and Two Children* resuscitates the motif of the seated female figure that Gauguin had used in Paris when he painted *Annah the Javanese* (Plate 40), and to which he was to return the following year in *Woman with a Fan* (Plate 47). In both these works the figures are strangely isolated in space, staring impassively forward with the static quality and crisply delineated shadows that suggest a photographic source. The theme of maternity seems to have haunted Gauguin at this time. A painting of 1902 in the Bührle Foundation, *The Offering*, returns to the subject of mother and child. Except for the occasional portrait, Gauguin rarely painted older women, and the archetypal figure she represents is in stark contrast to the sexually alluring young women who populate his later work.

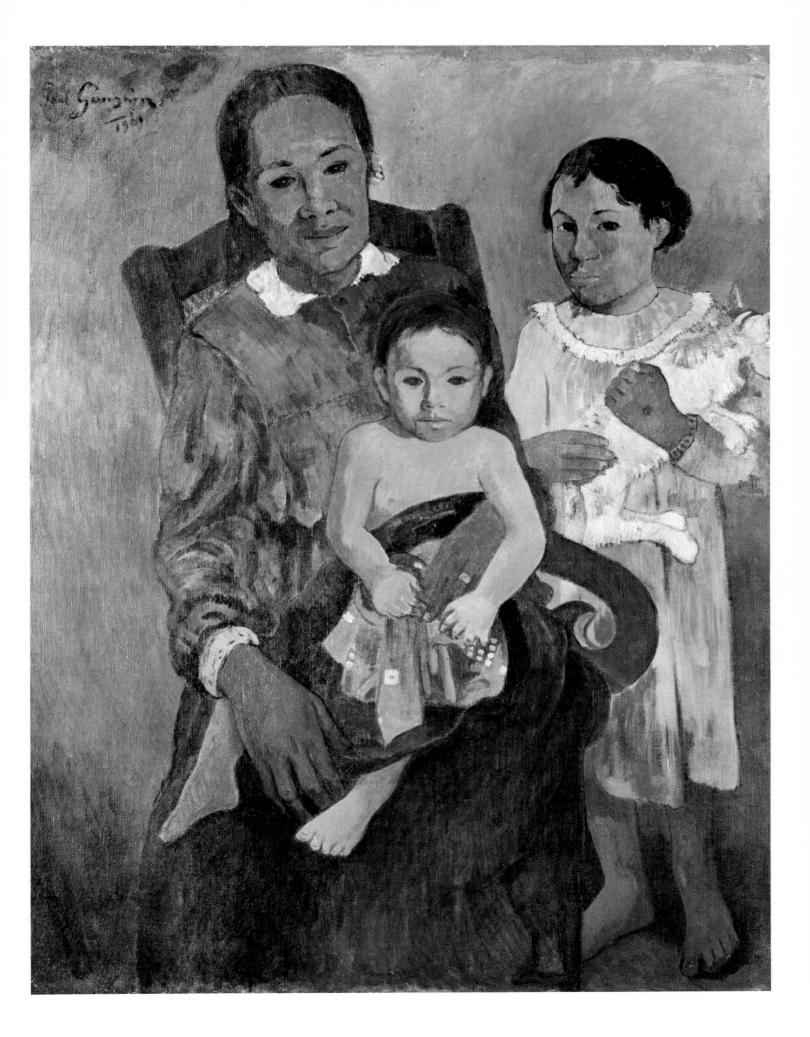

47 # Woman with a Fan

1902. Oil on canvas, 92 x 73 cm. Essen, Folkwang Museum

The model for this work, Tohotaua, reappeared in *Contes Barbares* (Plate 48), but the painting itself was based on a photograph of the woman taken in 1901 and found in Gauguin's effects after his death in Hivaoa. Although the pose in the painted version is broadly similar to that in the photograph, Gauguin has made a number of important changes. Instead of coolly appraising the viewer as in the photograph, the woman here gazes into space, and the mood is not unlike that in *Faaturuma* (Plate 29). The *pareo* with which Tohotaua covered her breasts in the photograph, has been changed and the image becomes much more overtly erotic. The position of the fan has been moved slightly, so that it covers her right breast in a provocative fashion, not unlike the fruit in *Ea haere ia oe?* (Plate 37). In making these changes, Gauguin has constructed an image of an archetypal Polynesian woman, passive and sexually available.

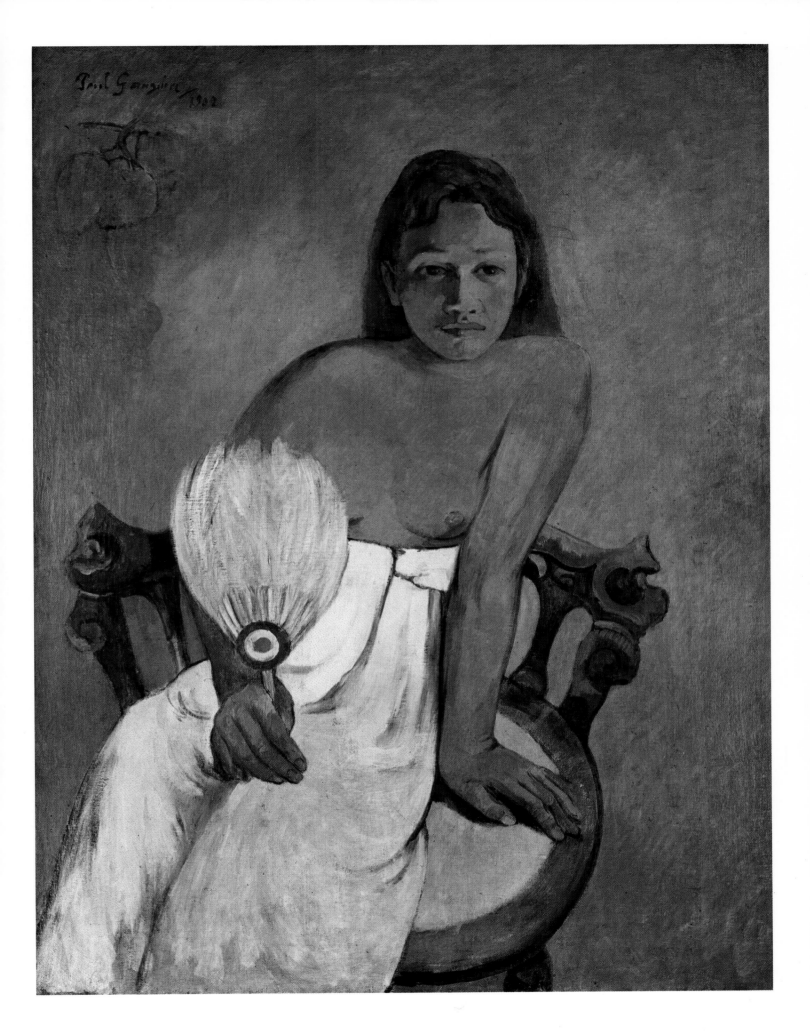

Contes Barbares (Primitive Tales)

1902. Oil on canvas, 130 x 89 cm. Essen, Folkwang Museum

Fig. 29
Nirvana (Portrait of Jacob Meyer de Haan)
1889. Oil on linen, 20 x 29 cm. Hartford, Ct., Wadsworth Atheneum

In his late paintings, produced on Hivaoa, Gauguin seems to have attempted a reconciliation between his Western past, and the more 'savage' Polynesia. Nowhere is this more evident than in *Contes Barbares*. The West is represented here by the figure of the painter Meyer de Haan, whom Gauguin had not seen since they had worked together in Brittany. The liberty that Gauguin has taken with this portrait, and the suggestion of a demonic aspect to Meyer de Haan's character, implies a West that is necessarily corrupt. The Orient, on the other hand, is represented by two stoical Polynesian figures, the red-haired figure of Tohotaua, who was portrayed in *Woman with a Fan* (Plate 47), and the dark-haired woman who sits in a classic Buddhist pose, perhaps a quotation from Borobudur.

The meaning of the title is not clear. In his last works, Gauguin had abandoned his earlier practice of naming his paintings, but he made an exception here. The steady gaze of all three figures suggests that any communication is conducted with the spectator rather than within the picture space itself.

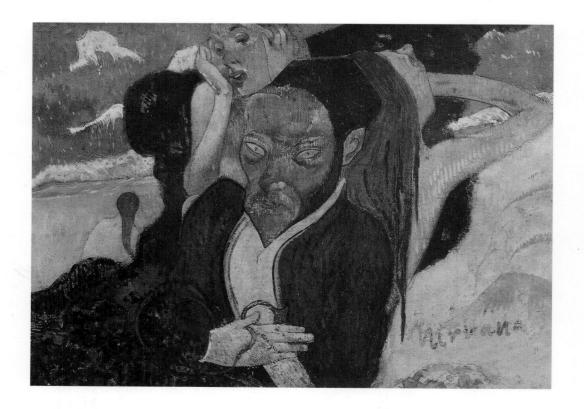

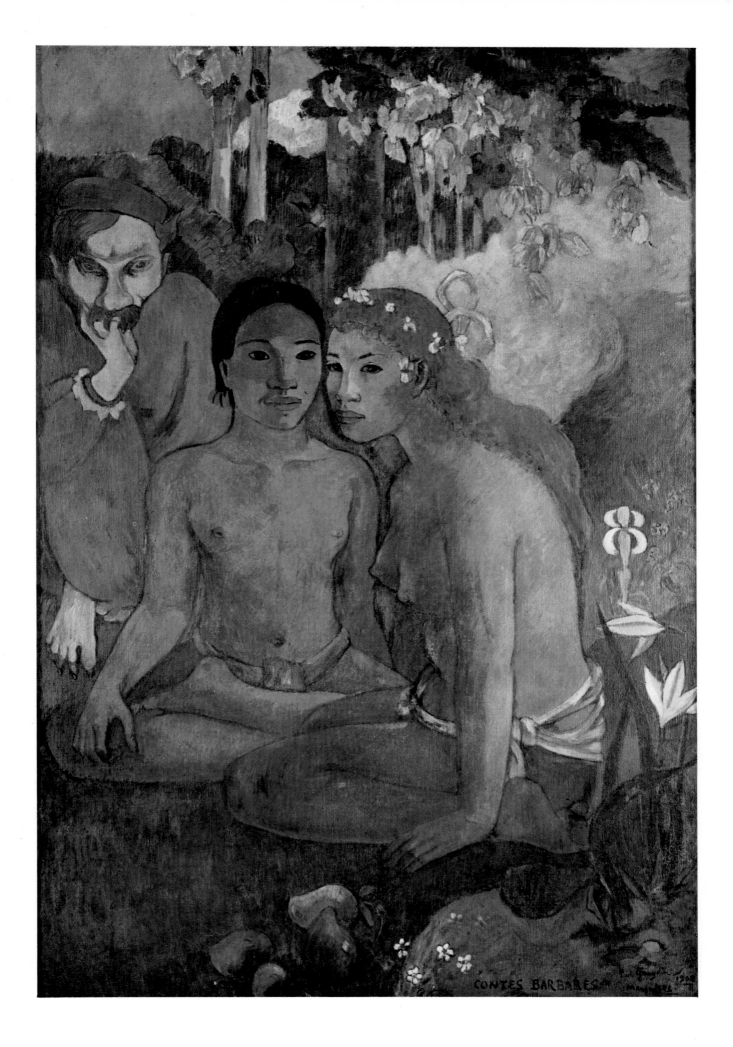

PHAIDON COLOUR LIBRARY

Titles in the series

BRUEGEL
Keith Roberts

CEZANNE
Catherine Dean

GAUGUIN
Alan Bowness

JAPANESE COLOUR PRINTS
J. Hillier

KLEE
Douglas Hall

MATISSE
Nicholas Watkins

MONET
John House

THE PRE-RAPHAELITES
Andrea Rose

PICASSO
Roland Penrose

REMBRANDT
Michael Kitson

SURREALIST PAINTING
Simon Wilson

VAN GOGH
Wilhelm Uhde

CONSTABLE
John Sunderland

MANET
John Richardson

RENOIR
William Gaunt

DEGAS
Keith Roberts

MODIGLIANI
Douglas Hall

TURNER
William Gaunt

MAGRITTE
Richard Calvocoressi